Photographic credits

AIC Photographic Services, Leith, Edinburgh
Cat nos: 4, 7, 9, 10, 11, 12, 13, 14, 15, 16, 18, 19,
20, 21, 22, 23, 24, 25, 26, 28, 29, 30, 31, 32, 33, 34,
35, 36, 37, 38, 40, 42, 43, 44, 45, 46, 47, 48, 49, 50,
52, 53, 54, 58, 59, 70, 71, 72, 73, 74, 77, 78, 79, 80,
81, 82, 84, 85, 86, 87, 94, 95, 96, 97, 98, 103, 106

ill. nos: 1, 3, 5, 7, 9, 10, 11

Estate of Michael Peto
ill. no. 14

Andy Dewar, Aberdeen
ill no. 16

Glasgow Print Studio
Frontispiece, ill. nos: 17, 18, 19, 20

Graphic Studio, Dublin
ill. no. 21

Marilyn Muirhead, Glasgow
Cat. nos: 17, 27, 41, 51, 55, 56, 57, 60, 61, 62, 63,
64, 65, 66, 67, 68, 69, 75, 76, 83, 88, 89, 90, 91, 92,
93, 99, 100, 101, 102, 104, 105, 107, 108
ill. nos: 2, 6

Media Services Photographic, University of Glasgow
Cat. nos: 1, 2, 3, 39, 109
ill. nos: 1, 4, 8

Mercury Gallery, Moreton Ongar, Essex
ill. no. 15

Reeve Photography, Pampisford, Cambridge
Cat. nos: 5, 6, 8

Estate of Ronald Wilkie, Hunterian Art Gallery,
University of Glasgow
ill. nos: 12, 13

Selected Bibliography and Exhibitions 1999–2002

Within the limits of this publication, a complete catalogue of the artist's prints has taken precedence over a full listing of the bibliography and exhibitions that record Elizabeth Blackadder's work as a whole. On these matters, the reader should refer to Duncan Macmillan's *Elizabeth Blackadder*, the first citation below. What follows is a supplement, updating the listings to August 2002.

Monographs:

Duncan Macmillan, *Elizabeth Blackadder*, Scolar Press, Aldershot, 1999 (ISBN 0-7546-0063-7)

Selected Newspapers:

David Stuart, 'Plants prove a model of inspiration', *The Sunday Times*, 30 August 1998

Phil Miller, 'It's Blackadder: by royal appointment', *The Sunday Times*, 4 February 2001

Aidan Smith, 'A Brush with Royalty', *The Scotsman*, 6 February 2001

Leila Farrow, 'My Schooldays: Elizabeth Blackadder', interview, *The Scotsman*, 14 March 2001

Douglas Carr, 'Here by Floral Appointment: My Garden, Elizabeth Blackadder', interview, *The Herald*, 7 July 2001

Selected Group Exhibition Catalogues:

Scotland's Art, texts by Duncan Macmillan and Murdo Macdonald, City of Edinburgh Museums and Galleries, 1999 (ISBN 0-905072-86-3)

Artists at Harleys: Pioneering Printmaking in the 1950s, text by Christopher Allan, Hunterian Art Gallery, University of Glasgow, 2000 (ISBN 0-904254-73-9)

Solo Exhibitions:

1999
Mercury Gallery, London

1999–2000
Scottish National Gallery of Modern Art, Edinburgh

2000
Talbot Rice Gallery, University of Edinburgh

2001
Elizabeth Blackadder – Printmaker, originated by Glasgow Print Studio, touring to Bonhoga Gallery, Shetland Christopher Boyd Gallery, Galashiels Browse & Darby, London

Selected Group Exhibitions:

1998
Art from Scotland, Forbes Magazine Galleries, New York

1999
Scotland's Art, City Art Centre, Edinburgh
Seven Scottish Painters, Solomon Gallery, Dublin
The Royal Scottish Academy, Albemarle Gallery, London

2000
Artists at Harleys: Pioneering Printmaking in the 1950s, Hunterian Art Gallery, University of Glasgow

2001
SPACE: Portfolios, Glasgow Print Studio
Black Pool: The Graphic Studio, Dublin, Glasgow Print Studio

2002
Contemporary Scottish Art 3, Falle Fine Art, St Helier, Jersey
The Fleming Collection, Town Hall, Kirkcudbright
Scots Abroad, Fleming Collection Gallery, London
160th Anniversary Exhibition, The Scottish Gallery, Edinburgh
Alive and Printing – The Third Decade: A Celebration of 30 Years of Glasgow Print Studio 1972–2002, Glasgow Art Gallery and Museums, Kelvingrove
Mirror Mirror – Self Portraits by Women Artists, National Portrait Gallery, London, and tour

Elizabeth Blackadder Prints

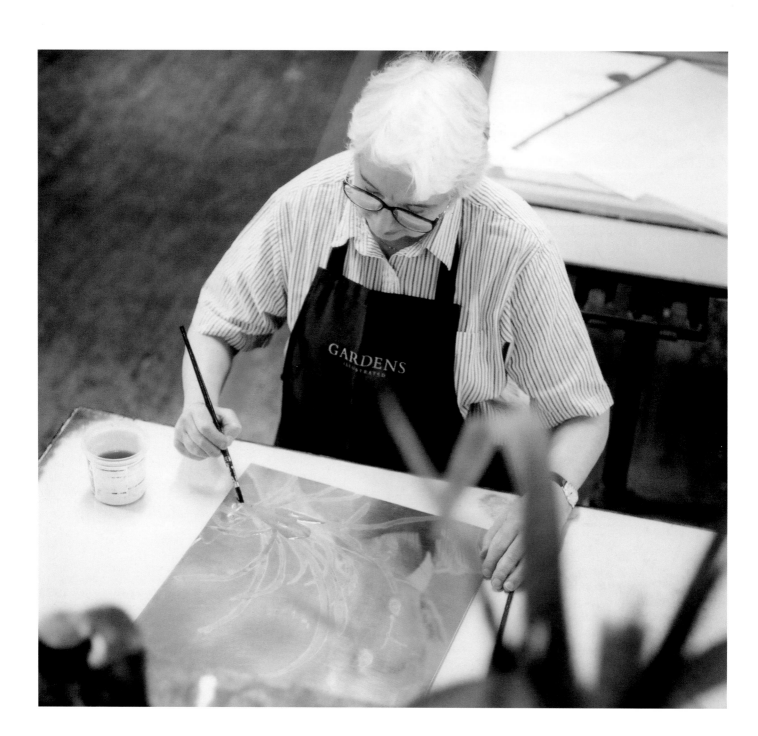

Elizabeth Blackadder Prints

Christopher Allan

Lund Humphries

First published in 2003 by
Lund Humphries
Gower House, Croft Road, Aldershot
Hampshire GU11 3HR
and
Suite 420, 101 Cherry Street, Burlington
VT 05401, USA

www.lundhumphries.com

Lund Humphries is part of Ashgate Publishing

British Library Cataloguing-in-Publication Data
A catalogue record for this book is available from the British Library

Library of Congress Control Number: 2002112207

ISBN 0 85331 855 7

Designed by Mick Keates
Originated, printed and bound in Italy by EBS

Frontispiece: The artist spit-biting *Orchid Miltonia No. 1* (Cat. 104),
painting ferric chloride directly onto the copper plate. (Coll. Glasgow Print Studio.)

Contents

For my mother, and in memory of my father

Preface and acknowledgements

Although a number of books and exhibition catalogues have been published on the art of Elizabeth Blackadder over the years, none has been able to afford detailed consideration of her work as a printmaker. Two years ago Lund Humphries offered me the opportunity to rectify the situation by proposing to publish a book devoted entirely to that subject.

I was happy to accept, for I had long admired Elizabeth Blackadder's prints. In addition, many years ago she had encouraged my first blundering steps in painting; perhaps now I could make some recompense, if only by putting one catalogue entry in front of another and hoping for the best. My intention has been helped enormously by the commitment of the publisher to reproduce every editioned print and to allow space for a detailed catalogue of them all. I have also been given the opportunity to illustrate some of the artist's working proofs and to feature a number of the people who have helped her to realise her ideas. All these people are due acknowledgement.

First are my thanks to the artist, for Elizabeth Blackadder patiently endured hours of questioning and cheerfully allowed me to rummage in her archive for days on end, leaving piles of proofs and studies in heaps about her well-ordered rooms 'for future reference'. All that bother, and delicious lunches too! John Houston has been invaluable in remembering her 'lost' early works – and rooting them out – and expanding on the broader background to her, and indeed his own, interrelated activities and travels that bear on printmaking. All good artists draw well, but few draw a cork as well as John Houston, and I am grateful for his demonstrations.

For detailed information on many aspects of the artist's printmaking from the earliest times, I am indebted to Johnston Douglas, Stanley Jones, Gillian Raffles, Andrew Purches, Arthur Watson, Stewart Cordiner, Sarah Uldall, Kip Gresham and James O'Nolan. The majority of Elizabeth Blackadder's prints have been made at Glasgow Print Studio, where I have received much help and guidance from John Mackechnie, Stuart Duffin, Norman Mathieson and David Palmer, while Carolyn Nicol and Leona Stewart have allowed me a free run in photocopying records and raiding the transparency files.

Several of the above have also cast helpful and corrective eyes over aspects of my text,

but for a thorough overview, thoughtful criticism and the eradication of a shocking number of errors, I am indebted to Pamela Robertson and Peter Black at Glasgow University's Hunterian Art Gallery.

Proofs of prints not in the artist's possession have kindly been made available for study and reproduction from the Harley Brothers archive on deposit at the Hunterian Art Gallery, and from Stanley Jones's archive at Curwen Chilford Prints.

It would have been impossible to have enhanced the book with so many and so varied a range of reproductions without the collaboration and consent of photographers and photograph copyright holders. I thank them all generally here, and credit them all specifically on p. 128.

My final acknowledgement is a heartfelt 'thank you' to my partner Marion Jackson, who has patiently borne with a deal more fuss than the writing of a little book like this should generate.

Chris Allan
Prestwick
April 2002

Printmaking processes

Over five decades, Elizabeth Blackadder has explored a wide range of printmaking media, embracing lithography, etching, aquatint, drypoint, woodcut, screenprint, carborundum print and monoprint. The history of her versatile production is the main subject of this book. This first short chapter outlines the different media that Blackadder has used, drawing attention to the special characteristics of each and illustrating how the artist has exploited them to her creative advantage.

Whatever the medium, it is essential to emphasise that the goal in every case is to create an *original print*, as opposed to a reproductive print. That is to say, the artist has worked out in her head and through her hand to make, on the printing surface or matrix, all the marks that combine into the final image from which the prints are taken. These prints are inspected for consistency then signed and numbered by the artist, and the editions are strictly limited, generally to fifty impressions but sometimes to no more than ten or twenty. The plates or other surfaces on which the design was made are then destroyed. In contrast, a *reproductive print* is one in which the image – an already completed drawing or painting – is photographed, then photo-mechanically colour-separated and printed as a 'facsimile' of the original work. Unfortunately, many reproductive prints are also issued in large 'limited editions', but no amount of signing and numbering of them by the artist who made the design will make them original prints, any more than signing the illustrations in this book will make them the *original prints* they reproduce. Elizabeth Blackadder has rigorously avoided the reproductive print market; she has the desire and the skills to offer the public the real thing. All her prints have been produced – often quite literally – from scratch. Of course she has benefited from the expert advice of master printers when making many of these works, and once she has perfected the final image, she relies on their skills and time to pull consistent editions, working from the *bon à tirer* or agreed proof. The contributions of several of these craftspeople are noted in this book. But this collaboration does not diminish the originality of the work, any more than the originality of Wren is diminished by the knowledge that he did not build St Paul's Cathedral single-handed.

Lithography

Lithography exploits the basic fact that grease and water do not mix. On a limestone block, or finely grained zinc or aluminium plate, the artist creates a design with a black greasy crayon, or uses diluted greasy ink to make washes with a brush or fine lines with a pen. Provided that the greasy ink, or *tusche*, is used, any type of mark is possible. Some chemical processing to fix the image is needed, and the areas

not drawn on are sealed with gum arabic (also used as a binder in water-colour paints). Before printing the image, the surface is dampened with water, which is absorbed by the gummed areas. A thin layer of oily printing ink rolled over the surface will be repelled from these areas but will be attracted to the drawn areas. Under the pressure of the lithographic press, the image is then transferred to a sheet of paper, which then becomes a basic lithograph. Because the printing surface can hold a very thin film of ink, lithography is an ideal medium for colour printing. An image can be built up in several thin layers of coloured inks with the advantage that they will also influence the resulting appearance by creating additional colours. For example, where a pale blue passes over a yellow there will be a green, where a dark blue passes over a strong orange there will be a near equivalent to black. Several working proofs survive of Blackadder's first lithograph, *Tuscan Landscape* (Pl. 1, Cat. 1), and are used here to illustrate the process in a simple form (ill. 1). Later in her career she was able to increase the number of stones or plates on which to build up her compositions. *Still Life and Fan* (Pl. 28, Cat. 9) involved the use of eight plates, and the colour mixing that could be achieved fostered a work as complex in colour and tone as a painting in oils or water-colour, but with a crisp quality all its own.

Etching

Etching is an offshoot of engraving. An engraver cuts – with great labour – fine grooves into a polished metal plate. To print the design, he covers the plate with oily ink and then carefully wipes it off the

ill. 1 The lithograph *Tuscan Landscape* (Cat. 1) was based on a large drawing in pen and wash (upper left). The line work and washes were freely redrawn on separate stones in black *tusche* ink, then proofed in black to check the quality (upper right and lower left). The printing process reverses the images. A mauve ink was chosen for the wash effects and printed first, with the line work overprinted in black (lower right). (Coll. Harley Archive, Hunterian Art Gallery, University of Glasgow.)

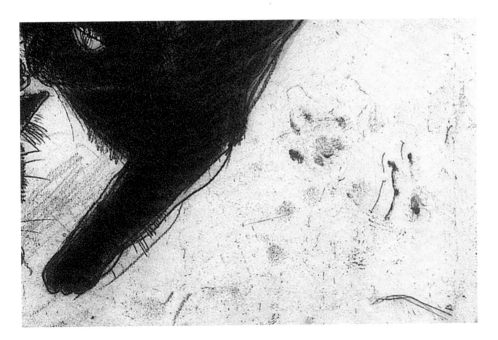

ill. 2 Soft-ground etching is very sensitive to pressure. In this detail, the paw mark from an inquisitive model for *Three Cats* (Cat. 57) and the artist's fingerprints were transferred to the plate in the drawing-up stage. They could have been stopped-out before the plate was bitten in the acid. Instead they were retained to reinforce the spontaneity of the work and to enrich its texture.

surface, leaving the residue trapped in the lines he has cut. He then covers the plate with damp paper and rolls both through a mangle press under considerable pressure. When the paper is peeled back from the plate the lines that were cut have been transferred to the paper as ink lines. Etching is a labour-saving variation, which allows greater freedom. While the inking and printing processes are the same as for engraving, etching differs in the way the plates are prepared. Rather than cutting the design into the metal by hand, the plate is heated and thinly varnished with a dark 'ground', an acid-resistant coating which sets at room temperature and can be drawn through easily with a needle point, exposing the metal surface beneath. The plate is then submerged in an acid bath where the acid will etch or 'bite' the exposed areas into ink-holding grooves. A variant, much favoured by Blackadder, is soft-ground etching. The ground melted onto the plate is soft and waxy and never sets. The surface is immediately covered with a sheet of thin paper, on which the artist draws with pencil or hard chalk. Under this light pressure, the waxy ground transfers from the previous metal to the absorbent paper, which is peeled off to reveal the design exposed in bare metal for acid biting in the normal way. This method faithfully transfers to the etching the qualities and texture of the drawing – and also any accidents that may happen in the process, as illustrated in ill. 2.

Aquatint

Etching can also be combined with another process, one that produces a continuous tone, ranging from palest grey to deepest black. This is aquatint, where a cloud of dust-size particles of resin is fanned or shaken to settle all over the plate, then gently fused to it when heated. The acid bites into the metal between the tiny particles. Normally, areas of the design are progressively stopped-out by covering them with varnish to protect them from further immersions in the acid bath, so that clear gradations of tone appear. This procedure is called step-biting, but Blackadder has specialised in a more spontaneous approach, rather unattractively called spit-biting, which softens and blends the tonal transitions. In a spit-bitten work the artist paints blobs of acid directly onto the aquatinted plate where the tonal effect is required. These small volumes of acid are only active for a few minutes, and must be re-applied several

Above: ill. 3 An early proof of *Banksia* (Cat. 43) with the seeding head of a species of Proteaceae, and added ink washes. (Coll. the artist.) Dissatisfied, Blackadder applied an aquatint ground and obliterated this area under successive applications of acid.

Below: ill. 4 Details of the two plates for *Orchid Miltonia* (Cat. 104), shown inked in their constituent colours. They were then printed (right over left) to combine into the final image. See Pl. 88. (Coll. the artist.)

times to achieve a rich depth of soft-edged tone. Throughout these applications the entire plate can be at risk from accidental spillages, which Blackadder, being an habitual risk-taker in creating her water-colours, has cheerfully exploited (Frontispiece). Her progress on making *Banksia* (Pl. 94, Cat. 43) is an apt illustration of her spit-biting skills.

Colour etching

Colour etching is another area in which the artist has made a distinctive contribution. Most commonly etchings and aquatints are printed in one colour – generally black – to obtain the full value of contrasts and gradations on a white paper. But etchings can also be printed in colour, though never in as large a range as in lithography or screenprinting. There are two basic ways to do this. In the first method, different areas of a design on a single plate are coloured *à la poupée* (with a little 'dolly' of rag for each ink), as was done with the artist's first etching, *Hibiscus and Cats* (Pl. 90, Cat. 14). Editioning becomes a laborious process taking much time and skill. In the second method different parts of the image are

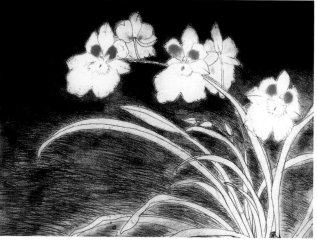

designed on two, sometimes three, separate plates. Each plate is inked in a given colour, and printed in succession to create the final image. Blackadder generally combines both these methods together, giving a 'how did she do that?' final effect. Ill. 4 is an example of how a colour etching develops. Variations can be made; one of the virtues of colour etching is the opportunity it provides for experiment. Both plates for *Red Still Life* (Pl. 40, Cat. 48) went through two states of alteration to the line work and the extent and strength of the aquatint *etc*, until the third and final state was reached. Then the fun began: in which colours and combinations of colours would it look best? In ill. 5 we can see the artist searching for the solution.

Above: ill. 5 Two versions from a sequence of trial colour proofs for *Red Still Life* (Cat. 48). (Coll. the artist.)

Drypoint

At the opposite extreme in intaglio printmaking is drypoint – the simplest technique of all. Here the artist simply scratches the design into the surface of a soft metal plate, such as copper or zinc. All that is needed is a sharp, heavy metal point and a strong grip. The drypointer does not have quite the freedom of the etcher – she must physically mark the surface, not just skate over it – but she can see and test her work as she goes, without the complications of stopping-out and acid baths to interrupt progress. The disadvantage of the technique is its fragility. Just as a plough throws up a ridge to excavate a furrow, so the drypoint needle throws up a ridge of metal, or 'burr', equal to the line scratched in. Both burr and line hold ink, but under the heavy pressure needed to print, the burr is soon squashed flat, and the design thinned to a shadow of its original self. To pull more than twenty or so impressions of a drypoint before its qualities begin to deteriorate is unusual, and Blackadder's printers have shown great skill in nursing some of her plates to yield forty consistent impressions.

Below: ill. 6 The burr of metal raised by a drypoint needle traps ink and prints with a rich soft line, especially noticeable along the lower back of the cat in the centre of this detail from *Studies of Cats* (Cat. 75).

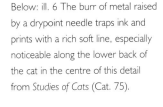

ill. 7 A detail from the woodcut *Strelitzia*
(Cat. 52). By cutting deep into the
background, some parts of this flower
are silhouetted against white, or
a vigorous grey hatching, while the
upper petals are defined in white line
against black.

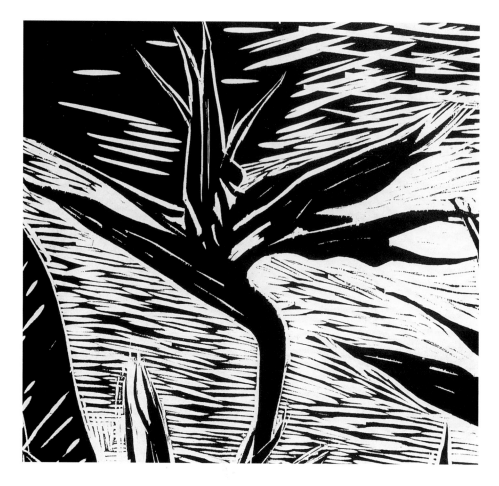

Woodcut

Woodcut is a form of relief printing, mostly made on blocks of wood or thick linoleum. The non-printing areas are cut away into the surface, leaving the design standing proud, or in relief. The entire surface is rolled-up with ink, but the platen press used (designed to exert an even downward pressure over all the surface at once) ensures that only the work lying proud on the block is transferred to the paper. The concept is simple – any inky fingertip can leave a 'relief print' – but even in monochrome the potential to design in black on white, or white on black, and to mix these two approaches, provides ample opportunity to transform this simple concept, as Blackadder did in the expressive design of *Strelitzia* (Pl. 101, Cat. 52).

Screenprint

Screenprinting is a sophisticated form of colour stencilling, using a fine-meshed fabric stretched tight onto a supporting frame. The usual method, as followed by Blackadder, is to create the design in a light-blocking ink or paint on a series of transparent films, generally allowing one colour per film. Each colour separation is then transferred directly to a separate screen through a light-sensitive emulsion. Once cured, the emulsion blocks up the holes in the mesh around the design. To print the design, the paper is placed on a table beneath the frame, and the ink is pulled across the upper surface of the screen with a rubber squeegee. This presses the ink through the open areas of mesh, replicating the design on the paper below. Bold and vibrant results can be created by overprinting in virtually opaque colours.

In recent decades the development of more sensitive films for drafting the design, combined with finer weaves of mesh, has also led screenprinting to rival lithography in the transparency of the ink film printed, and the optical colour effects that can ensue, a development that has appealed to Blackadder.

Carborundum print

This technique is a recent development, originating in the experiments of Henri Goetz and Christine Boumeester in the 1960s. Carborundum, a trademark name for silicon carbide, is an extremely hard industrial abrasive. For printmaking, powdered carborundum is mixed into a resin binder, then painted-out on a rigid support, such as an etching or litho plate; the design can be manipulated easily while the paste remains fluid. Once dry, the gritty texture will hold ink rather like aquatint, and the result is printed as for etching. A design separated out onto three or four plates can be inked and printed in sequence like a colour etching. Blackadder used clear acrylic sheets as the supports for her four carborundum prints, enabling accurate visual registration of the successive parts of each design. Unlike etching, the

ill. 8 In the screenprint *Still Life with Boxes* (Cat. 109), five separate colours of ink, varying in transparency, were used to build the subtle colours of the detail illustrated at bottom right. Whatever the colours envisaged, all design work must be made in a photo-opaque ink; a procedure familiar to the artist from her early lithographs.

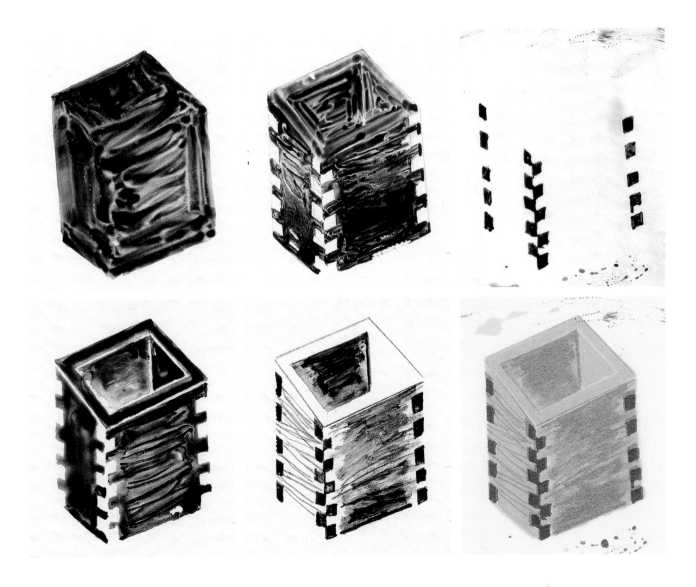

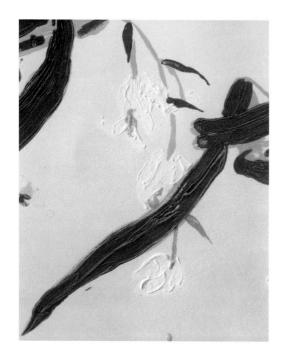

design sits proud of the plate, giving carborundum prints an embossed appearance, as the dampened paper distorts over the surface in the press. Painterly effects are its strength, though it suffers from a similar weakness to drypoint, as the pressure of the press gradually crushes the design, and editioning is restricted.

Monoprint

A monoprint, as the name suggests, is a one-off creation, and cannot be repeated. The method Blackadder has used is to paint separate components of a design in printing inks onto two or three smooth Perspex plates of equal size, printing each in succession through a large etching press to create the final image. A second version can be made by repainting the 'ghosts' of the designs left on the plates and then printing again, but a version it will be, not a replication. Monoprint is as much an experimental painting process, using a press forcefully to amalgamate the design, as it is a printmaking process, reliant on a press to replicate the design held in an original matrix.

Around 1990, Blackadder made ten or more large monoprints at Glasgow Print Studio. Being unique works, rather than editioned prints, they are not catalogued in this publication. But the monoprint process is closely related to aspects of her printmaking, and a fine example of her use of the technique is illustrated here.

Above: ill. 9 The detail of the carborundum print *Coelogyne cristata* (Cat. 95), photographed in a raking light, reveals the bold impasto textures of the medium. The flowers were formed with carborundum paste, but not inked, printing as a blind embossing against the aquatint background.

Right: ill. 10 *Still Life*, 1992, monoprint, approx. 76 x 110 cm (30 x 43¼ in). (Private coll.)

The prints of Elizabeth Blackadder

lizabeth Blackadder first experimented with printmaking as a student in 1953, and her first published prints appeared in 1958. She has continued to make prints for over four decades, and 109 have been editioned to date. This essay provides a chronological account of her activities in this area. The broader canvas of her art has only been alluded to, where relationships of subject, style and approach have had a specific bearing on her prints. The first detailed account of her work and life as a whole was Judith Bumpus's *Elizabeth Blackadder*, Oxford, Phaidon Press, 1988, while Duncan Macmillan's *Elizabeth Blackadder*, Aldershot, Scolar Press, 1999 also contains much recent material. Reproductions of paintings in both books are cited below, as sources of comparative images.

Student days

After leaving Falkirk High School in 1949, Elizabeth Blackadder studied for the degree of Fine Art offered jointly by the University of Edinburgh and Edinburgh College of Art. This exacting course was taught by both institutions over five years, its students marching daily from college to university and back, in pursuit of artistry on the one hand and art history on the other. At Edinburgh College of Art, Blackadder worked mostly with her art school colleagues in the Drawing and Painting School. Printmaking was not part of the curriculum; in those days it was not usually taught to aspiring painters in Britain's art schools. Printmaking equipment would be found in the 'commercial art' or 'design' department, the techniques largely taught as craft skills serving future graphic and textile designers and trade printers. Any student of painting who wanted to make prints would have to make an effort outside normal tuition. Blackadder took evening classes in etching during 1953, under Murray Tod (1909–74), head of the Department of Engraving in the College's School of Design from 1949 to 1959. He was a skilful topographer, but Blackadder recalls his droll narrative scenes with many little figures scurrying about, and her first attempts, all genre subjects, may reflect this approach. The most elaborately worked etching was a kitchen interior with a young boy's *Bathtime,* though an earnest *Self Portrait* (ill.11) was perhaps the most successful.

Harley Brothers Ltd

From the mid 1960s, reflecting the growth of print publishing in the wider world, printmaking gradually evolved as a legitimate adjunct to painting and sculpting courses, enabling many

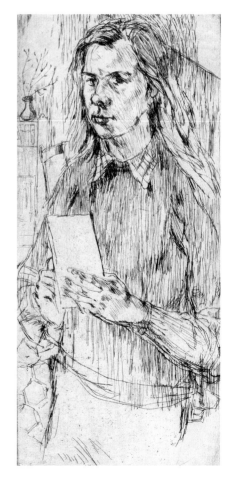

ill.11 *Self Portrait,* 21 × 10 cm (8¼ × 4 in), a student etching from 1953. (Coll. the artist.)

more students to have access to basic instruction in the different disciplines. In a growing number of schools, fine art printmaking became a degree course in its own right, such as that established by Philip Reeves in Glasgow in 1970. However, in the late 1950s, well in advance of these developments, artists in Scotland were briefly in the unique position of having access to a commercial lithographic printers in Edinburgh – Harley Brothers Ltd. A speciality of the firm was the production of elaborately printed labels for several hundred brands of alcoholic refreshments. It was undercapitalised and had remained longer in the stone age of lithography than most of its competitors, who were already investing heavily in rotary offset presses and photo-mechanical reproduction. Johnston Douglas, Harley's managing director from the early 1950s, sought to exploit the traditional skills of its craftsmen by offering an editioning service to artists. In 1956 he began with John Piper, who had previously sought out the skills of Parisian lithographers, like Mourlot Frères, to create his lithographs. Other artists from the south – Alistair Grant, Michael Ayrton and Terry Frost – soon followed (ill. 12). With the support of the Scottish Committee of the Arts Council, some fourteen distinguished Scottish painters were offered the opportunity to create prints there in 1957–8. They included senior figures, such as Anne Redpath and William MacTaggart, others in mid-career like Henderson Blyth and Robin Philipson, and a youthful Elizabeth Blackadder, aged twenty-six.

Blackadder made three lithographs at Harley's in the spring of 1958. The first, *Tuscan Landscape* (Pl. 1, Cat. 1) derived from one of the large drawings she had made in Italy in the winter of 1955–6 during her postgraduate travelling scholarship. The result was richer and more considered than the original drawing, whilst retaining the expressive power employed in creating it. The artist recalls feeling rather out of her depth with this first attempt in a new medium, unsure if anything worth looking at would result. In fact, *Tuscan Landscape* was among the most successful of Harley Brothers' productions (ill. 13).

Her second lithograph, *Harlequin* (Pl. 24, Cat. 2), was a more complex exploration of printing in colour, using another strand of the artist's interests – still-life composition. The work was to be done on three stones, and was developed through trial compositions, using transparent coloured inks. Two studies in the artist's possession explore combinations of blue, green and sienna inks. The final drawing, in a warm palette of green, sienna and yellow, was adopted in drawing-up and proofing the lithograph. Several elements from an experimental 'test-stone' were incorporated, including the pair of pears, the rough shape of the chalice and the spiralling leaf forms of the plant at the left. These elaborate and thoughtful preparations testify to the young artist's ability to grasp and exploit the potential of colour printing.

In addition to these hand-printed lithographs, Blackadder created a smaller image, drawn up on zinc plates for printing on Harley's offset press. These light plates could be carried off to be developed in her studio. For this project Blackadder again referred to her Italian sketchbooks, choosing a pencil study of the Duomo in Lucca. While this closely observed topographical record is the source, she had the confidence to transform it into painterly printmaking terms and to introduce a mysterious dark rider on a white horse, passing through the deserted piazza of *San Martino* (Pl. 2, Cat. 3). By the end of 1959, Johnston Douglas had overseen the editioning of some 114 subjects by thirty artists, and it was quite possible that Blackadder would have returned to work at Harley Brothers. Sadly, difficulties with the profitable marketing and distribution of this stock of prints, allied to the gradual decline of core trade business, led to the closure of the firm in the early 1960s.[1]

Above: ill. 12 Johnston Douglas with proofs of the lithographs *Three Somerset Towers* by Piper and *Acrobats* by Ayrton, Harley Bros., 1957. (Coll. Harley Archive, Hunterian Art Gallery, University of Glasgow.)

Below: ill. 13 The artist with printer Jimmy McFarlane at the press, examining progress on *Tuscan Landscape* (Cat. 1), Harley Brothers, 1958. (Coll. Harley Archive, Hunterian Art Gallery, University of Glasgow.)

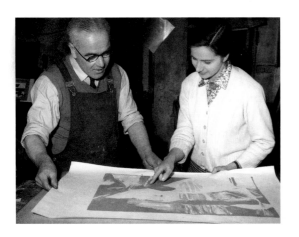

St George's Gallery Prints and the Curwen Studio

Through her work at Harley's, Blackadder met the Hon. Robert Erskine, then a pivotal figure in advancing printmaking in Britain. While an undergraduate in Cambridge, Erskine developed a keen interest in modern printmaking, enlarging his knowledge in Paris during 1954–5. In November 1955 he opened a gallery in London – St George's Gallery Prints – dedicated to the promotion of contemporary graphic art. His aim was to champion British printmaking, and he commissioned a number of English artists to work at Harley's, and handled some of the Scottish prints, including Blackadder's, that had been made in Edinburgh. He also believed that professional lithographic editioning, dedicated to serving the creative artist without commercial distractions, could be established in London as it existed in Paris. With the encouragement of both Erskine and his former teacher Ceri Richards, Stanley Jones, a graduate of the Slade, spent most of 1956–8 in Paris, learning the necessary skills at first hand in the Atelier Patris and other studios. On his return, the Curwen Press set up a dedicated workshop – Curwen Studio – for Jones to operate, near to their main premises in Plaistow (ill. 14). It is to be celebrated that, over forty years on, Stanley Jones continues to offer his expertise to artists as studio director of Curwen Chilford Prints Ltd near Cambridge.[2]

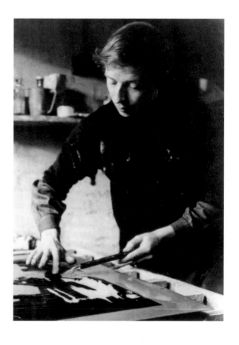

ill. 14 Stanley Jones at work in the first Curwen Studio, Plaistow, 1959. (Coll. Stanley Jones.)

Impressed by Blackadder's first lithographs, Erskine commissioned her to make new prints at Curwen Studio. So it was to Plaistow, in East London, that Blackadder travelled from Edinburgh to work with Stanley Jones on three occasions in the early 1960s. On her first visit she created *Fifeshire Farm* (Pl. 3, Cat. 4) and *Dark Hill, Fifeshire* (Pl. 5, Cat. 5). The former would be distributed by Erskine himself, while the latter was a commission he was handling for the Museum of Modern Art in New York. Both were inspired by the landscape near Burntisland, opposite Edinburgh on the north bank of the Firth of Forth. Blackadder and fellow painter John Houston had married in 1956. His family lived in Fife, and her familiarity with the area grew from their frequent visits. At that time she had a preference for winter landscapes, and in *Fifeshire Farm* she graphically exploited the tangle of bare black branches and building silhouettes to create a vigorous framework, supporting freely applied tints of yellow and umber. The 'dark hill' of the second print is The Binn, which rises behind Burntisland. *Dark Hill* was developed from several large-scale drawings in pen and ink and in heavily worked black chalk, culminating in a loosely executed gouache, made to guide the drawing-up of the three lithographic stones. Stanley Jones recently recalled:

> 'There was a freshness and directness in the approach of some of the Scottish artists then – Alan Davie was the prime example, also William Scott – and Elizabeth took to that approach too. The colour separations were not aligned tightly to the key drawing, and she became progressively more painterly. If you look at the use of semi-opaque colour in *Dark Hill, Fifeshire*, for example, you see how she made it hold everything together, like a piece of painting or gouache work.'[3]

The result is the most assured of her early prints; there may be echoes of her mentors, Robert Henderson Blyth and William Gillies, but it is highly individual, with the white of the paper brilliantly exploited to convey the effect of snow.

In 1962 Blackadder was commissioned by the General Post Office to make a large lithograph of *Staithes* (Pl. 4, Cat. 6) for distribution as a poster. This was part of a programme of patronage that brought many British artists' work to brighten the interiors of post offices throughout the land, using the exhortation: 'Please use your correct address.' Curwen Press was contracted as printer, and the GPO was generous with its budget, allowing eight plates to create the print. The palette Blackadder could employ was thus far wider than before. She spent a few days sketching on the Yorkshire coast and then

returned to Plaistow where she worked with Jones to proof the image in Curwen Studio, prior to editioning on the rotary offset machine at Curwen Press. The extant proofs, on Crisbrook waterleaf paper, are a little richer, and the colour more blended, than in the final poster. Jones recalls a plan for an initial limited edition on this fine paper, but the artist never signed it. Crown copyright restrictions may have prevented its appearance. Before the final run of about 1600, a grey tint border and the necessary lettering were added. Blackadder deployed a strong black graphic framework, tensioning and tying together the bare bones of the composition. The result is dramatic – for Blackadder, verging on melodramatic – with Staithes headland thrusting into a wave-tossed sea as a great bulwark of protection for the huddle of the village and its harbour.

The artist last visited Curwen Studio in 1963, again to work on commissions from Erskine. This time it was to develop a group of landscapes on a subject congenial to them both – Hadrian's Wall. Erskine had read archaeology at Cambridge, and was later to abandon promoting prints in favour of creating film and television documentaries on that subject. Blackadder in younger days had explored Hadrian's Wall in the company of her relative, William Bulmer, then curator of the Roman Museum at Corbridge. Jones's records indicate that four subjects were planned – a suite of prints, as favoured by Erskine – but in the event only *Roman Wall I: Castle Nick* and *Roman Wall II: Walltown* passed the proofing stage. The former (Pl. 6, Cat. 7), is a view of Castle Nick (Milecastle 39), looking east to the distant crest of Hotbank Crags. Her approach to it reflected her growing confidence as a painter. Her initial drawing was a detailed linear exploration of the topography and aspects of the stonework in the wall. But this was only a reference to guide a full-scale gouache in a loosely applied palette of brown, green and grey. The structural form of the landscape is expressed through the unprinted white of the paper, giving a painterly, rather than graphic, emphasis to the final image.

Walltown (Pl. 7, Cat. 8) had as its source a carefully observed and annotated sketch in pen and ink, and tinted washes across two pages of a sketchbook. It was also the subject of at least one painting, the large *Wall Town* of 1961 (Macmillan, Pl. 7). Although in the print the principal topographical features of the sketch are preserved, the use of white reserved areas combined with black creates a dynamic balance of 'drawing', integrated with the warm pink of the sky and the deep yellow of the foreground. It is a far richer effect than Blackadder had been able to create using three not dissimilar colours in *Fifeshire Farm*, just three years earlier (Pl. 3, Cat. 4).

Looking back over the six years from 1958 to 1963, Blackadder had published eight prints and had trialled at least four others. She had in a short time become adept in lithography, experienced, inventive and commercially successful. Looking forward, we have to grapple with a curious fact – sixteen years were to elapse before she made another print. Her simple answer is 'Nobody asked me!', which immediately begs the question 'Why not?'. There is no easy answer. During the 1960s and into the 1970s, the creation of original prints in Britain expanded rapidly. While a wealth of new imagery in Pop and Op art, in Hard-edge abstraction and Photo-realism was introduced, a wide variety of more traditional approaches to printmaking was still published and marketed to an increasing audience. On the other hand, Blackadder began a full-time teaching commitment at Edinburgh College of Art in 1962, by which time her abilities as a painter had been recognised through two one-person shows in Edinburgh. Her paintings had also been included in a growing number of group exhibitions in Edinburgh, in London and in Canada. In addition, she began a long association with the Mercury Gallery in 1965.

The Mercury Gallery and the Senefelder Press

Gillian Raffles opened her Mercury Gallery in Cork Street, London in May 1964. Her main objective was to promote the work of younger contemporary painters she personally admired, an activity that demanded regular and continuing support from some judicious dealing in the 'early modern masters'

area of the salerooms. Blackadder had her first show there in 1965, inaugurating a pattern of biennial exhibitions until Raffles retired in 2001 (ill. 15). Gillian Raffles was not seriously involved with the burgeoning market for contemporary prints; her direct experience indicated that the majority of collectors of paintings were not also habitual print collectors, and vice versa, an observation that the artist confirms. However, Blackadder's success, and Raffles's growing client base, decided Raffles to commission and sell directly some new prints from an artist whose abilities had lain dormant for so long. For the first of these commissions, Blackadder worked with Andrew Purches, who had studied lithography at Winchester School of Art at the start of the 1960s. Subsequently, he became involved in the commissioning and marketing of contemporary prints for a number of publishers, including Curwen Studio and the Collector's Guild of New York, and had also worked with Raffles at the Mercury. Around 1970 he set up his own press and editioning service, registering it as the Senefelder Press in 1980.[4] In November 1979, Blackadder came down to London to begin work with Purches on two prints, *Still Life and Fan* (Pl. 28, Cat. 9) and *Cats and Flowers* (Pl. 25, Cat. 10).

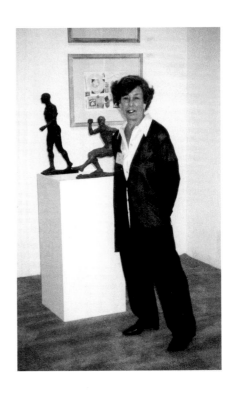

ill. 15 Gillian Raffles of the Mercury Gallery has represented the artist for over 35 years. She is seen here exhibiting works by Blackadder and Frink at a Chicago Art Fair. (Coll. Gillian Raffles.)

Still Life and Fan was markedly different from her first still-life lithograph, *Harlequin* (Pl. 24, Cat. 2). Over two decades, her interest in still-life composition and its abstract arrangement had progressed markedly in paintings and watercolours, and Raffles underwrote the opportunity to create an image which fully reflected her acquired experience. Rather than the three stones of *Harlequin*, this print was created using eight plates, exploiting all the colour combinations that arose. Several of the objects, including the chinese fan, were bought at the time in Covent Garden, and the print began life as a series of rough designs, not a fixed idea. Objects were introduced, altered, removed or re-positioned, allowing the image to develop through an extensive series of annotated progressive proofs. Purches recalled that to obtain the depth of tone of the black mat without the ink deposit becoming heavy and clogged, he overprinted the area four times. The result, an image in parallel to her paintings, fully justified the effort required of both artist and printer.

Blackadder followed this with the similarly sized *Cats and Flowers* (Pl. 25, Cat. 10), this time using only six plates and reflecting the informal approach she had perfected in similar watercolour compositions around that time (see Macmillan, Pl. 23). She worked it up from a tiny rough pencil sketch, not a transcription of a completed work. It was a deliberate attempt to create anew the informality of her watercolour approach, and to convey it, using Purches's skills, into printed form. The background was first created from the texture of an inked sheet of Japanese tissue, and given added richness by overprinting in a flat tint of a second grey. Two contrasting greens were printed from one plate; having captured the delicate washes, the plate was resensitised and partially reworked to create the areas of solid dark green. The popularity of the imagery of *Cats and Flowers* led to the entire edition of seventy-five being bought within a year or two of publication.

Printmaking at Peacock

Peacock Printmakers in Aberdeen (renamed Peacock Visual Arts in 2001), was founded in 1974. It was the third (Edinburgh Print Workshop, 1968; Glasgow Print Studio, 1972) but by no means the last of a series of communal workshops to emerge in Scotland. With support from the Scottish Arts Council and other charitable trusts, coupled with membership fees and profits on sales of work, all these workshops aimed to provide facilities for new generations of printmakers, whose access to college equipment as students could hardly be replicated through personal ownership after graduation. To help underpin the service and promote the workshop's skills, Arthur Watson, Peacock's ebullient young director, offered

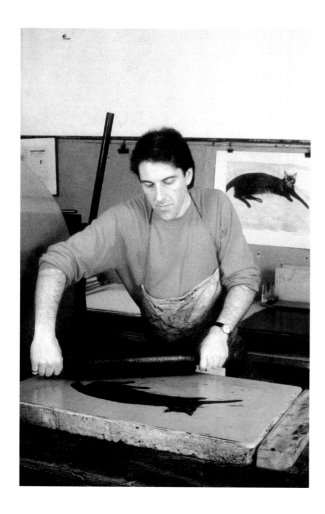

ill. 16 Stewart Cordiner, then
lithography technician at Peacock
Printmakers, inking up one of the two
stones for *Black Cat* (Cat. 12) in 1982.
(Coll. Peacock Visual Arts.)

to edition or co-publish prints by established artists. He recalled: 'In the case of Elizabeth's prints, I think we were approached directly by Gillian Raffles, because at that time we were the only workshop in Scotland with a history of making lithographs from stone.'[5] Following the success of the works made in London with the Senefelder Press, Raffles commissioned three further lithographs to be made at Peacock. Half of each edition would be sold through the Mercury Gallery, the balance going to Blackadder's American dealer, the Lillian Heidenberg Gallery in New York.

The first of these new prints was *Still Life with Indian Toy* (Pl. 29, Cat. 11) of 1982. John Houston had been collecting and experimenting with a variety of oriental papers in his work from the 1960s, and more recently, Blackadder had begun to use such papers to support many of her watercolours. Following on from her exploration with Purches of printing the texture of a Japanese paper as the background to *Still Life and Fan*, Stewart Cordiner, Peacock's litho technician, enabled her to use such fragile papers directly, by first backing them on to heavier sheets. *Still Life with Indian Toy* relates closely to watercolours of the period. The dancing bear motif appears in the much larger and more elaborate *Still Life with Indian Toys* of 1981 (Bumpus, Pl. 58). The muted colour harmony, in which inclusions of bark within the pulp of the Yamato Chire Japanese paper effectively adds three more colours to the mix, is related to the earlier *The Black Fish*, 1978 (Macmillan. Pl. 38). The transition of expression from water-colour to lithography seems quite effortless, and the subtle application of bronzing powder (a technique best known to printers of whisky labels) to achieve the gold-leaf effect is superbly done.

While working in Aberdeen, it was decided to create a second, simpler lithograph, *Black Cat* (Pl. 48, Cat. 12), which Blackadder could develop at home. Technically this was a straightforward affair, as two prepared stones were sent down for her to draw up in her Edinburgh studio – a relaxation from the complexities of previous work. Cordiner was able to process an image more akin to the sketchbook than the studio easel (ill. 16). While Blackadder went on to make more elaborate prints at Peacock, the simplicity of the means used in creating *Black Cat* points to the more direct expression of her graphic skills realised through her re-engagement with etching at Glasgow Print Studio three years later.

In the third print in this group, *Still Life with Wooden Puzzles* of 1983 (Pl. 26, Cat. 13), the artist explored a new medium: screenprinting. This was largely unintentional, for while screenprinting was Arthur Watson's particular speciality, its choice here had a pragmatic basis. The successful realisation of the favoured design required some twelve colours, and drawing up so large a succession of laboriously prepared lithographic stones would exceed any realistic editioning budget. By working the separations on film, transferred to screens, the edition could be afforded without compromising the range of colours planned. The transparency of effect might be lessened, but then Blackadder's use of quite strongly toned oriental papers in her painting often necessitated heightening her watercolours with white, to achieve more vibrancy and covering power. This approach was emulated through the screenprinting technique, with a range of transparent to semi-opaque inks applied to a Japanese tissue bonded to a heavier backing. The final broad black washes were created lithographically, as they may have looked solid and clogged if screenprinted.

Etching in Glasgow, 1985–6

Early in 1985, John Mackechnie invited both Blackadder and Houston each to make an etching with him at Glasgow Print Studio. After a decade as a print technician and lecturer at Brighton and Newcastle Polytechnics and in Glasgow, Mackechnie was appointed director of the Studio in 1983, in difficult economic circumstances. Like Watson in Aberdeen, he was keen to enlarge Glasgow's editioning and publishing potential to raise both its profile and income, not least because of the need to move to better-equipped premises. Blackadder's only experience of etching was from her student days over thirty years before, so this was to all intents a new beginning. She immediately took to the medium. In contrast to the preceding lithographs which were, broadly speaking, creative equivalents to painting or gouache, she found in etching a direct freedom of expression akin to sketching, and a medium of great graphic potential (ill. 17).

The first fruit of Mackechnie's invitation was *Hibiscus and Cats* (Pl. 90, Cat. 14). With its sophisticated use of space, and the spontaneity of the spit-biting technique, it was a serendipitous debut. The plate was originally thought of in monochrome black, the *à la poupée* colour inking being a suggestion of Mackechnie, who was himself a gifted colour etcher. The artist holds it dear, both in itself and because it inaugurated the use of a new technique, in which she became phenomenally productive. Previously, Blackadder had published 13 prints over a period of 27 years. From 1985 to date she has published a further 96, of which the vast majority, 78, are etchings in one form or another. All but one of these etchings (Pl. 50, Cat. 72), have been editioned in Glasgow Print Studio.

Following the success of *Hibiscus and Cats*, Blackadder began experimenting with a group of five smaller soft-ground etchings, all to a predetermined size. They included *Flower* (Pl. 92, Cat. 15), a study of a *Meconopsis* poppy – her first etching to be printed in colour from two plates – and *Landscape in Japan* (Pl. 8, Cat. 16). The latter was a view of Matsushima Bay, deriving from the artist's first visit to Japan, which she and John Houston made in the Easter of 1985. Two other Japanese lake scenes were then abandoned, but the first state of *Iris* was subsequently augmented with further flower studies in hard ground (Pl. 93, Cat. 19). Gillian Raffles was keen to promote this new development, publishing editions of *Flower* and *Landscape in Japan* in a specially bound booklet. This marked both the Blackadder exhibition she presented at the Edinburgh Festival in 1985 and the coincident twenty-first anniversary of the Mercury Gallery. Raffles was to continue this practice in subsequent years, commissioning further small colour etchings to enhance beautifully bound limited editions of Judith Bumpus's *Elizabeth Blackadder* (*Little Kyoto Still Life* and *Black Cat and Lily*, Pls 36 and 49, Cats 39 and 40) in 1988 and Deborah Kellaway's *Favourite Flowers* (*Irises* and *Salpiglossis*, Pls 104 and 105, Cats 73 and 74) in 1994.

The potential of colour printing by combining two plates, tentatively explored in *Flower*, was immediately developed on a larger scale in two further etchings. Invited to contribute to a portfolio in aid of the World Wildlife Fund, to be editioned at Camberwell School of Art, Blackadder created *Meconopsis and Butterflies* (Pl. 91, Cat. 17). However, Camberwell rejected the plates, objecting to the 'foul biting'. These background marks, caused by accidental – and deliberate – scuffing of the plates through the soft ground, added atmosphere and texture which the artist and the staff at Glasgow felt quite in keeping with the general draughtsmanship of the subject. Therefore it was published by Glasgow Print Studio, and the World Wildlife Fund project was left to reproduce a painting instead. An even larger two-plate etching of an *Orchid* (Pl. 64, Cat. 18), explored

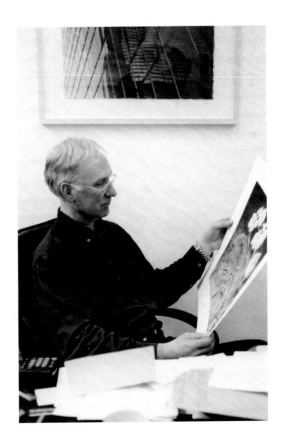

ill. 17 John Mackechnie with a proof of the etching *Orchid Miltonia No. 1* (Cat. 104), Glasgow Print Studio, 2002

the rich possibilities of the spit-biting technique, allied to the varied line – here firm, there broken and crumbling – that her draughtsmanship could obtain through soft-ground etching. Richly inked in red, yellow, green and black, this image became the archetype for the range of flowers – plant portraits as much as botanical studies – to be created in subsequent years.

Three etchings were completed in 1986, including the previously mentioned *Iris*. In *Beetles and Flowerheads* (Pl. 30, Cat. 20), the plate was lightly ruled into a grid of squares, each containing a separate study. Objects that Blackadder had collected on her visit to Japan in the spring of 1985, such as brush rests and T-shaped scroll weights, contributed to the imagery of *Japanese Still Life* (Pl. 27, Cat. 21). Its composition is related to such watercolours as *Still Life, Hiiragiya* (Bumpus, Pl. 89). Among the largest of Blackadder's etchings, it is comparable in ambition to the lithographic still lifes of 1979–83.

New opportunities, 1987–8

After twenty-five years of lecturing at Edinburgh College of Art, Elizabeth Blackadder took early retirement in the summer of 1986. Freed from these duties her productivity rose dramatically, not least in printmaking, and 1987 saw her begin over fifteen new etchings. These included two landscapes, four still lifes and nine large plant portraits, chiefly of orchids. Stuart Duffin, one of Britain's foremost mezzotint printmakers when not acting as studio manager and etching technician for Glasgow Print Studio, now took on Mackechnie's role as master printer, assisting the artist with registration and proofing, and organising a growing roster of printer–etchers to edition the results (ill. 18).[6]

The landscapes, *Lotus Pond – Akita* (Pl. 9, Cat. 26) and *Loguivy de la Mer, Brittany* (Pl. 10, Cat. 27), derive from sketchbook observations and, made largely in line alone, preserve that spontaneity. This is also the case with *Japanese Table* (Pl. 31, Cat. 24), where two separate plates are printed together and transformed by inking in two distinct colours. *Indian Still Life* (Pl. 32, Cat. 22), with the now familiar areas of 'foul bitten' textured ground, stood up in its own right in black, but on completion of the edition the artist developed a second plate in spit-bitten aquatint, and a new version emerged (Pl. 33, Cat. 23) inked in red, green, yellow and ochre, and thus very different in effect. *Parrots* (Pl. 34, Cat. 25) counts as a still life too, for all the birds are toys from the Blackadder menagerie. A set of proofs survives,

ill. 18 Stuart Duffin, studio manager at Glasgow Print Studio, with Elizabeth Blackadder, examining a proof, 2002. Nearly all of the artist's etchings have been editioned on this Harry Rochat press. (Coll. Glasgow Print Studio.)

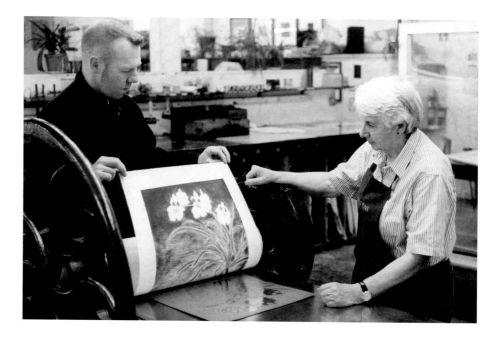

showing the artist extending her etching skills by experimenting with progressive overworkings and re-bitings, starting from a broad sketch in line alone, and working through four states to conclude in the rich penumbra of the published print. The final still life, *Still Life with Iris* (Pl. 35, Cat. 38), was a project for the National Art Collections Fund, which commissioned four distinguished British artists to make a limited edition of prints in support of its recently formed Modern Art Fund. The others were John Piper, Craigie Aitchison and Edward Bawden. Blackadder decided to create a variation on the compositional type of the previous year's *Japanese Still Life*, but one far bolder in approach and richer in effect; a testament to the rapid development of her aquatinting skills. It was also the first of several etchings to incorporate metal leaf – in this case twenty-two carat gold – which the artist had been applying to great effect in many watercolour compositions since the later 1970s.

The other area of special interest for Blackadder in 1987 was the development of her quasi-botanical plant portraits. The *Orchid* of 1985 had shown the way, and now the artist began to ring the changes on it. The enormous *Orchid Oncidium* (Pl. 68, Cat. 28), *Orchidaceae – Paphiopedilum insigne* (Pl. 65, Cat. 32,) and *Orchidaceae – Phalaenopsis* (Pl. 67, Cat. 34) are closest to the initial approach, with soft but incisive line drawing supported generally with aquatint. *Orchidaceae – Brassia gireoudiana I* (Pl. 70, Cat. 30) was intended as the key plate for a two-plate colour print, but the outline seemed too powerful to combine successfully with aquatint, so it was issued as an independent work. A colour version (Pl. 71, Cat. 31) was then begun by offsetting a proof of the outline onto an aquatinted plate. Traces of the outline, which protected the new plate from the acid, can be seen as white lines through the green foliage. Thus the plant emerges in pure aquatint, a parallel with working in watercolour, and an approach also taken with the superbly liquid execution of *Orchidaceae – Dendrobium atroviolaceum* (Pl. 66, Cat. 29), in which the only etched work is confined to sharpening up detail in the minute flower-head. *Orchidaceae – Bulbophyllum rothschildianum* (Pl. 72, Cat. 33) combines both these approaches, with a tracery of leaves in soft line alone on the right balancing an enormous drooping aquatinted flower-head and some artfully 'accidental' spillages of acid on the left. Completing this series of orchids was *Orchidaceae – Masdevallia* (Pl. 69, Cat. 35), the most overtly 'botanical' in approach, grouping specimens of leaf and flower from several species of the genus, drawn in line alone. The final plant in this group was a species of *Tillandsia* (Pl. 96, Cat. 36), whose wiry leaves arch gracefully across and into the depth of the sheet.

In addition to these etchings, Blackadder returned to lithography, making *Auratum Lily* (Pl. 98, Cat. 37) at Peacock Printmakers with Stewart Cordiner in 1987. Cordiner also returned to Peacock – he was now teaching at Aberdeen College, so the proofing was developed over several weekend visits. This intended commission by the Royal Scottish Academy offered the opportunity to explore and capture in printed form an equivalent to the large plant studies the artist had been perfecting in watercolour since 1979, not least the similar *Auratum Lilies* of 1985 (Bumpus, Pl. 65).

Printmaking, 1989–92

Up to 1988 it has been possible – albeit often in summary fashion – to characterise Elizabeth Blackadder's prints individually. This approach cannot be sustained for the remaining seventy or so subjects she has created without writing at a length this book is not designed to encompass. Regretfully, comment must focus on groups and types of work, singling out some individual images, and letting their merits stand for other, similar prints.

One important factor in the technical development of Blackadder's etchings arose from Glasgow Print Studio's move to new premises in King Street in 1989. There was room to install ferric chloride baths dedicated to etching copper, separate from the more powerful nitric acid baths formulated for steel plates. A highly polished surface can be more easily prepared on copper, and while it is arguable

whether copper enables richer effects and finer detail to be obtained than does steel, its softer structure allows much easier adjustment with the burnisher and scraper. Blackadder was keen to explore the nature of copper, and she used it for almost all her subsequent etchings. In these years the majority of her images were conceived on a smaller scale than the previous sequence of orchids. Of the earlier plates, *Black Iris* (Pl. 97, Cat. 42) is among the finest. Almost heraldic in presentation yet delicately alive in detail, it was first proofed in colour, but the range and subtlety of the aquatint was best captured in monochrome. A similarly striking print is *Banksia* (Pl. 94, Cat. 43), which in its early days also contained a head of a *Proteaceae* species that the artist came to dislike (ill. 3). Many patient applications of spit-biting ensued until the area was completely obliterated with a dense amorphous black cloud. Blackadder remains proud of that depth of tone, and printer Stuart Duffin equally proud of doing it full justice in the editioning. Investigations into colour etching produced the tiny glowing *Little Doorway, Kyoto* (Pl. 38, Cat. 45) in black and red with overprinting in metallic gold, and the brilliant contrasts of *Konchi-in, Kyoto* (Pl. 42, Cat. 54). A visit to the temple of Konchi-in had made a deep impression on the artist, and it was first the subject of a large oil, *Gateway, Konchi-in Temple, Kyoto*, completed in 1991 (*Elizabeth Blackadder*, exh.cat., London, Mercury Gallery, 1991, Pl. 4). This was redesigned as an etching in a series of sketches using watercolour pencils to break down the best colour combinations for each plate.

Only one large plant portrait appeared in these years: the magnificent *Fritillaria imperialis* (Pl. 100, Cat. 50) of 1989, worked on two inexpensive steel plates due to its large size. It began life as a delicate but incisive black outline, but in the final print one is hardly conscious of any line work, which quietly takes its place among the various tones of aquatint. Towards the end of this period, in 1992, Blackadder made three large etchings on copper, in what might best be described as a 'muscular' style. One was a vigorously drawn and shaded study of *Three Cats* (Pl. 52, Cat. 57), similar to many of her drawings in chalk and charcoal. It emulated them in the way that preliminary drawing and surface marks – a cat's paw included – were left to characterise the design, rather than being treated as errors to be stopped out before the plate was bitten (ill. 2). The second, *Two Cats* (Pl. 53, Cat. 58), was a more formal composition. Both cats were vigorously sketched in using a broad pencil over a soft ground; the brown cat was then etched over through a hard ground to suggest fur, while the black cat was heavily aquatinted. The contrasts in form and texture created by these variant techniques graphically convey the tension of the cat poised to spring down and the relaxation of the other, dozing on the windowsill. The third large etching was in line alone, but a bold and varied line, conveying form, texture and distance in a manner reminiscent of Anthony Gross. This work, *Fishing Boats at Loguivy* (Pl. 12, Cat. 59), depicting a favourite holiday destination in Brittany, did not stem from a current visit, but was traced and adapted from a drawing made in 1979. At that time it might have led to an oil or gouache – the artist could never have imagined it as an etching. Thirteen years later she realised how suitable it would be to re-interpret in the medium she had subsequently mastered. She asked the editioning printer, David Palmer, to wipe the plate selectively, leaving a broad swathe of surface ink, or 'plate tone' to darken the foreground.

In addition to this group of etchings, Blackadder made a further lithograph – her last to date – and experimented with woodcut, a medium new to her. The lithograph of *Irises* (Pl. 99, Cat. 47) was commissioned by Edinburgh University and created at Edinburgh Printmakers Workshop with Sarah Uldall. Only one stone was used, and this was either regrained, or the image reduced, after the proofing and editioning of each colour. It was a method favoured by Uldall for encouraging spontaneity, but one unfamiliar to the habitually spontaneous Blackadder. Once each progression was decided, Uldall and workshop director Robert Adam laboured into the night to print each phase of this large edition of 175 prints. The project was well worth the effort, for the fluidity of the controlled washes developed

in this lithograph, and the transparency of the inks, surpass previous works, even the *Auratum Lily* of 1987. The result is directly comparable to the artist's use of watercolour in the extended series of Irises made from c. 1980 to the present day (eg Bumpus, Pls 64, 66, 68; Macmillan, Pl. 29).

The woodcuts were made in Glasgow Print Studio, where there had recently been a surge of interest in the medium by several major artists, including some sophisticated colour work by John Houston. This culminated in the exhibition *Scottish Woodcuts*, held at the Studio in 1988. Blackadder explored the medium in the following year, confining herself to cutting single blocks. With *Lilies* (Pl. 95, Cat. 51) she began to feel her way, and in her second attempt, *Strelitzia* (Pl. 101, Cat. 52), vigorously gouged out in silhouette, she achieved a strikingly successful integration of figure and ground. However, the medium is not perhaps sympathetic to the fluidity of her drawing style or her acute appreciation of tonal values, and she has not returned to it.

The *Orchid Portfolio*, 1991–3

Blackadder's interest in orchids predates her first prints of them. They certainly featured as subjects in the botanical drawing class she established at Edinburgh College of Art in 1981, in association with the Royal Botanic Garden in Edinburgh. Ten years later, in 1991, it was announced that Glasgow would be host to the 14th World Orchid Conference in May 1993. Glasgow Print Studio immediately invited her to create a substantial new group of orchid prints in portfolio form, to be published to coincide with the event, when she would also be having her first print retrospective at the Studio.

On that occasion she wrote: 'Intrigued by orchids, I have drawn and painted them for many years now. I have been helped to understand and appreciate at least a little about this fascinating family of plants by Paddy Woods of the Royal Botanic Gardens in Edinburgh.' Her choice of orchids was a subjective one: 'I chose the plants which appealed to me as an artist and which I found visually exciting in terms of shape, colour and structure. I make no claims to botanical truth or accuracy.'[7] Preliminary drawings, partially completed in watercolour, were made over a period of twelve to eighteen months, as flowering seasons dictated. Most were taken within the ordered surroundings of the botanic gardens of Edinburgh and Glasgow, though *Dendrobium 'Fire Coral'* (Pl. 76, Cat. 62) was blooming in Penang, Malaysia as the artist passed through, and was immediately recorded. A detailed exploration of *Coelogyne cristata* (Pl. 87, Cat. 95) extended over several sketchbook pages. Unfortunately it did not make the portfolio due to an error in the paper dimensions. At one point the artist's list of possibilities had risen to fifteen species, eventually reduced to ten portfolio subjects, all of the same size and mostly worked on two copper plates. Unlike a conventional set of botanical illustrations where consistency of approach would be paramount, Blackadder varied her response to her subjects. In some, like *Paphiopedilum insigne* (Pl. 75, Cat. 61), the entire plant is given an equal weight of emphasis, while in *Cambria 'Living Fire'* (Pl. 81, Cat. 67) and *Odontoglossum grande* (Pl. 83, Cat. 69) the vegetative parts are barely indicated with a wiry outline and the vibrant colour of the flowers is dominant. In others, *Brassia verrucosa* (Pl. 78, Cat. 64) and *Masdevallia dracula bella* (Pl. 80, Cat. 66) the botanist's device of emphasis through enlargement of detail is exploited.

At the end of the project Blackadder decided to work up a further orchid subject, *Phalaenopsis antarctica* (Pl. 86, Cat. 71), and to treat it in a novel way. Probably this study of a moth orchid was created using reserve plates for the portfolio, as it has identical measurements. It differs in conception by adding a dark background against which the 'moths' tremulously flutter. It is also unusual in being one of only two colour etchings that have required three plates (see *Two Exotic Fruits*, Pl. 37, Cat. 44). Blackadder was pleased to force up the white of the flowers with this painterly approach, in contrast to the more linear description and focussed colour areas that were a necessary consideration throughout the portfolio.

Etchings, 1994–7

The *Orchid Portfolio* had been a major undertaking, and the artist reduced the printmaking side of her activities in the following year or so. As a relaxation from the complexities of colour registration, she began a small group of cat studies, not on the grand scale of those of 1992, but intimate little prints in drypoint like the wary *Roman Cats* (Pl. 56, Cat. 76) or the inquisitive *Hong Kong Cat* (Pl. 60, Cat. 77) observed on her travels. In single plate etchings she could exploit the rich tonal contrasts of the pelts of her own cats, like Fred, beautifully portrayed grooming in *Black and White Cat* (Pl. 59, Cat. 79). She has continued this practice over recent years with further intimate drypoints of *Roman Cats II* (Pl. 58, Cat. 99) and of *Fred* (Pl. 61, Cat. 100) in 2000.

However, two more ambitious etchings emerged in 1996–7. Of these, *Lilium* (Pl. 108, Cat. 83) was a mature example of the quasi-botanical mode she had developed. The contrasts of pure line work with aquatint are beautifully balanced, while a dynamic effect of growth was created by the upsurging mass of the leaves of *L. pyrenaicum*, the central subject. On the other hand, *Autumn Kyoto* (Pl. 43, Cat. 81) was created in emulation of a pleat-folding Japanese album, and derives from recollections of Blackadder's several visits to Kyoto and studies from her growing collection of everyday Japanese objects. It was developed from a suggestion by Gillian Raffles as a special project for the artist's 1996 Mercury Gallery exhibition. Blackadder began with a fascinating preliminary drawing, in part full scale, in part filled with variant studies of the chosen family of objects. The print is composed in individual sections, to be viewed in the hand, one or two at a time, yet they also merge gracefully together when the entire book is opened out. The two plates, over 140 cm (55 in) long, were cut in half to fit into the acid bath, and the sections butted together during printing on Glasgow Print Studio's large motorised press (ill. 19). Areas of metal leaf were then burnished down, and Japanese seals, reading *Iris, Kyoto* and *Nippon*, were stamped on in red ink. Finally, the print was folded, and bound with silk-covered boards by Carronvale Bindery, with the related *View of a Garden* (Pl. 44, Cat. 82) inserted to give purchasers an item to display.[8]

ill. 19 The artist at work on *Autumn Kyoto* (Cat. 81) in Glasgow Print Studio, 1996. (Coll. Stuart Duffin.)

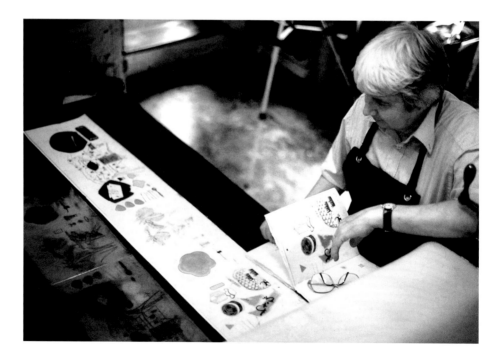

New media: Screenprinting and Carborundum prints

Blackadder first made a screenprint at Peacock Printmakers in 1983 (Pl. 26, Cat. 13). She decided in 1997 to re-engage with the technique she had last used fifteen years before, working with Norman Mathieson at Glasgow Print Studio. Mathieson, trained at Glasgow and Dundee, had been working at the new Northern Print Studio in North Shields, before being appointed screenprinting technician at Glasgow Print Studio in 1996. They worked on three prints in succession, of which the first was *Koi Carp, Chion-in* (Pl. 62, Cat. 84), the largest print she has ever made. It was not proofed, but simply begun and developed intuitively to its final form during the editioning process. The gradual build up of many colours overall gave it a painterly quality, akin to working in gouache or oils, and in both subject and effect it was quite new in her printmaking. It was followed by *Tulips* (Pl. 106, Cat. 85) and *Irises* (Pl. 107, Cat. 86), both superficially similar flower subjects but with markedly different approaches. Unlike Blackadder's etchings of flowers, which exploit particular characteristics of the medium, setting them apart from her watercolours, *Tulips* was an attempt to parallel the appearance of a large watercolour composition. It does not quite come off, for there is a certain stiffness and opaque solidity resulting from the printing of some twenty-six colours. In the following *Irises* however, the number of screens was restricted to eight, and, to capture more subtlety of detail and transparency in overprinting, the separations were painted on Autotype's True-Grain film, a material far more sensitive than the traditional Kodatrace film. There was a great gain in informality and delicacy of handling, though this does not quite approach the marvellous fluidity of the *Irises* in lithography of a decade before (Pl. 99, Cat. 47).

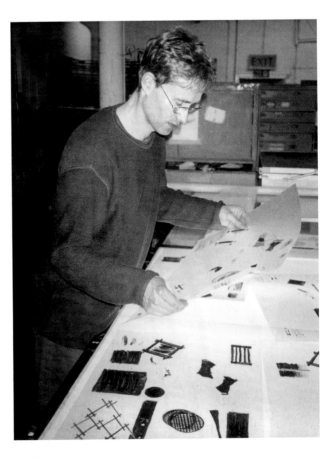

The artist has made two further screenprints since that group, *Still Life with Pagoda*, also of 1997 (Pl. 46, Cat. 87), and *Still Life with Boxes* of 2001 (Pl. 47, Cat. 109). Both deploy a familiar repertoire of Blackadder's oriental motifs, both exploit the delicacy of True-Grain film, and both use a similar number of colours. Yet they are a notable contrast, the first being enclosed where the second has no boundaries, the second being subtle and muted where the first is bright and gay. *Still Life with Pagoda* was made with Kip Gresham of Gresham Studio in Cambridgeshire, but the artist was unable to visit, working instead on a broad colour guide, painting out separations at home and correcting proofs through the post. The project was a portfolio of eight women artists – mainly American – to celebrate the tenth anniversary of the National Museum of Women in the Arts in Washington. To balance his selection, Gresham felt it essential: 'to include someone whose work was clearly by a feminine hand, but was in no overt way feminist, nor concerned specifically with female imagery'.[9] The recent *Still Life with Boxes* also formed part of a portfolio, one of two organised and published by Glasgow Print Studio in conjunction with an exhibition on the general theme of 'Space', staged in Glasgow in the autumn of 2001. It was editioned by Mathieson (ill. 20), and the subtlety of its colour structure is indicated in the details illustrated on p. 15 (ill. 8).

Another diversion from the general focus on etching came through an invitation from James O'Nolan, director of the Graphic Studio, Dublin, to experiment with carborundum prints.

ill. 20 Norman Mathieson, screenprinting technician at Glasgow Print Studio, with separations for *Still Life with Boxes* (Cat. 109). (Coll. Glasgow Print Studio.)

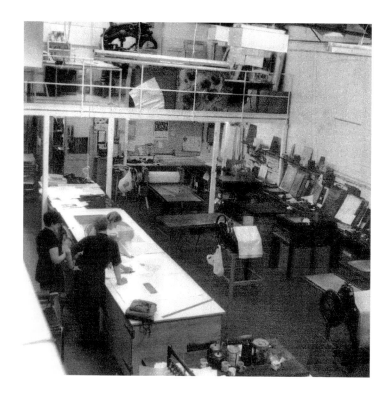

ill. 21 The interior of Graphic Studio, Dublin, where the artist's four carborundum prints were made in 1999. (Coll. James O'Nolan.)

Graphic Studio originated in a communal basement workshop in 1961 – some years earlier than any of the Scottish workshops – and opened in its current location near Temple Bar in 1988 (ill. 21). While offering all the standard techniques, O'Nolan and master printer Tom Phelan had experimented extensively with carborundum printing methods, and it had become something of a house speciality. Fellow Scot, Barbara Rae, who had already visited, recommended the process to Blackadder, who went to Dublin in the autumn of 1999. There she made four prints, each involving three or four plates. If the results are remarkable, the work rate of both artist and studio was equally so, as all were created – and the two largest reached final proof stage – over a long weekend! Blackadder found a natural affinity with the process, for just as she had worked her aquatint by manipulating the acid on the plate with a brush, here she could paint the fluid carborundum paste on in a similar way. The results are rich and painterly; the relief inherent in the process, printed onto a soft but bulky paper, gives a pronounced textural effect. This is very noticeable in a vigorous new study of *Orchidaceae – Coelogyne cristata* (Pl. 87, Cat. 95), while the *Japanese Interior, Kyoto* (Pl. 45, Cat. 96), has strong affinities with the large oil painting *Self-Portrait with Red Lacquer Table* (Macmillan, Pl. 65). The small Italian subjects, *Tempio dei Castori* (Pl. 22, Cat. 97) and the *Dogana* (Pl. 19, Cat. 98) also directly reflect the painter, being themes that have been developed in a number of small oils in recent years.

Etchings of the recent past

In her recent etchings, Blackadder has favoured small, lightly worked studies of Italian motifs, deriving from several winter visits, principally to Venice and Rome. Her affection for the feral cats that populate the Roman Forum (Pl. 56, Cat. 76; Pl. 58, Cat. 99), has already been noted (p. 28). The first of the Italian views form a group of five Venetian subjects: *Burano* (Pl. 16, Cat. 88), *Fishing Nets, Burano* (Pl. 15, Cat. 89), *Murano* (Pl. 18, Cat. 90), *Torcello* (Pl. 17, Cat. 91) and *Piazzetta* (Pl. 13, Cat. 92). Blackadder spent a week or so in the Veneto in the late autumn of 1997, drawing on the spot in the day and translating her studies onto etching plates in the evenings. The results are impressionistic, with general effects of light and movement on the lagoon, seen from casual viewpoints, taking precedence over topographical accuracy. Or so it may seem – but the apparently wonky spire beyond the piles that mark the navigation channel to *Burano* is just that: the leaning campanile of the church of San Martino. Only in the case of the *Piazzetta* did she reverse her work to ensure the correct orientation of the columns of St Theodore and the Lion of St Mark in the printing. Once bitten, no reworking or additions were made, and several of the plates were being editioned as early as January 1998.

Her next subjects, *Venice: High Tide* (Pl. 14, Cat. 101) and *Basilica San Petronio, Bologna* (Pl. 20, Cat. 102), derive from a similar visit late in 1998. They are equal in spontaneity but decidedly richer in line work, particularly in the *San Petronio*, where a strong tonal contrast between the marble-faced porticoes and the unfinished brick upper storey of the façade is developed with forceful horizontal hatching. Two Roman subjects followed in 2001–2: a view of the Augustan ruins in *The Forum, Rome*

(Pl. 21, Cat. 107), which was closely related in spirit to a similarly titled small oil (Macmillan, Pl. 57), and a second version of the *Tempio dei Castori* seen against the evening sky (Pl. 23, Cat. 108), previously developed as a carborundum print. In all of the above, but especially in the *San Petronio* and the *Tempio dei Castori*, there are a number of 'accidental' marks. These result from recycling previously used plates, creating new works on the backs of old, and accepting, enhancing and occasionally burnishing down the numerous scrapes and scratches and foul bitings that the backs of plates are always heir to. They convey an aged atmosphere most appropriate to their subjects.

This approach can also be seen in the delicate and slender upright *Orchid Paphiopedilum* (Pl. 85, Cat. 103) executed on the back of one of the panoramic Venetian views of 1997. Another slender and elegant plant is portrayed in the casually grouped stems and heads of *Iris – Hermodactylus tuberosus* (Pl. 109, Cat. 106), the artist's most recently completed flower print. In it is resurrected the simple but satisfying scheme of yellow-green and purple that the artist had first trialled and then rejected for her *Black Iris* of 1989. During 2000 the artist began work on a two-plate colour etching of *Orchid Miltonia* (Pl. 88, Cat. 104), which emulates the hovering, nocturnal, moth-like impression she first achieved with *Phalaenopsis antarctica* (Pl. 86, Cat. 71) in 1993. The results of progress proofing seemed so striking as to warrant creating another version, *Orchid Miltonia No. II* (Pl. 89, Cat. 105). Blackadder made this almost entirely in aquatint, to be editioned in monochrome.

In conclusion . . .

Following a review of this broad nature, some conclusion might seem appropriate. A tally of 109 published prints is an achievement that any painter might be proud of. But there can be no conclusion to an ongoing activity. Elizabeth Blackadder is presently busy with some new prints – etchings and maybe a lithograph – to which the author is not privy: 'I don't want to distract you, Chris … surely I won't have them ready before *your* deadline?' So far so good, but readers are assured that by the time this book is in their hands it will be incomplete, making conclusions premature while further variations are being added to the artist's catalogue of prints. For the author, 'variations' are the key; it is the artist's variety which strikes me as her most remarkable achievement in printmaking. To illustrate every work, the publisher has devised thematic groups of plates: landscapes; still lifes and interiors; animals; orchids; and other plant studies. This helpful convenience is in itself an indicator, for to be adept across these different genres is an ability few artists can possess. Moreover, in sampling any section, you will see that a wide variety of approaches and effects is revealed in each.

Many artists who are primarily painters restrict their printmaking to a safely trodden path: a favoured medium and method they know will give results. So too do many specialist printmakers, whose portfolios are often based on steady progress – hopefully imaginative as well as technical – in one or two chosen media they have made their own. In contrast, Blackadder's engagement with lithography, with drypoint, with etching, with aquatint, with woodcut, with screenprint and with carborundum print reveals her appetite for variety. This open-minded attitude has ensured that her particular sensibilities have been captured, in one aspect or another, whatever the apparent complexities of the process at hand. Moreover, the diverse ways she has found to express her vision within these different techniques, and her ability to deploy line and tone and colour – from simple monochrome to the full spectrum of the printer's palette – adds another layer of variety to her graphic works. Finally, the entirety of this large body of prints adds further variety to the œuvre of an artist famed for her oils and watercolours, and not merely as an adjunct to her main purpose. Gradually, over the years, the making of these prints has become one of Elizabeth Blackadder's main means of creative expression, and, from the simplest to the most complex of them, they never fail to provide some fresh and individual insight that makes each one a living, breathing work of art.

1 For a full account of Harley Brothers, see: Christopher Allan, *Artists at Harleys: Pioneering Printmaking in the 1950s*, Hunterian Art Gallery, University of Glasgow, 2000. The Hunterian Art Gallery holds on deposit a substantial archive of the artists' prints that were editioned by the company.

2 For further information on Curwen prints see: Pat Gilmour, *Artists at Curwen*, London, Tate Gallery, 1977, and Stanley Jones et al., *Curwen: Forty Years in Print*, the Curwen Studio, Cambridgeshire, 2000.

3 Stanley Jones in conversation with the author, 4 September 2000.

4 A reference to Aloys Senefelder, who invented the technique of lithography in 1798. Purches relocated his press to Upper Beeding in 1988, and has latterly concentrated on stone lithography at Cowfold, West Sussex.

5 Arthur Watson in correspondence with the author, 22 April 2002.

6 In addition to Mackechnie, Duffin and Mathieson, mentioned throughout the text, other staff and able members of Glasgow Print Studio, all creative printmakers in their own right, have applied their skills to the editioning of Blackadder's work over the years. The records include: Deran Fenwick, Ruth Greer, James McDonald, Alison McMenemie, Ian McNicol, Jacqueline Moon, Janie Nicoll, David Palmer, Elspeth Roberts, Murray Robertson, Joanne Traynor, Douglas Thomson, David Watt and Stuart Webb. The etcher David Palmer holds the palm for this exacting work, having pulled no less than twenty-three editions to date.

7 Both passages are quoted from the Introduction contained within the *Orchid Portfolio* itself, and reprinted in the booklet with an essay by Stuart Duffin, 'Elizabeth Blackadder: orchids and other flowers', Glasgow Print Studio, 1993, that accompanied the portfolio's first exhibiton.

8 In a letter to the author of 31 March 2002, Gillian Raffles recalled that a number of her Mercury Gallery clients had the notebook displayed open in an acrylic box frame, as well as framing the *View of a Garden*.

9 Kip Gresham in conversation with the author, 4 September 2000.

Plates

Landscapes

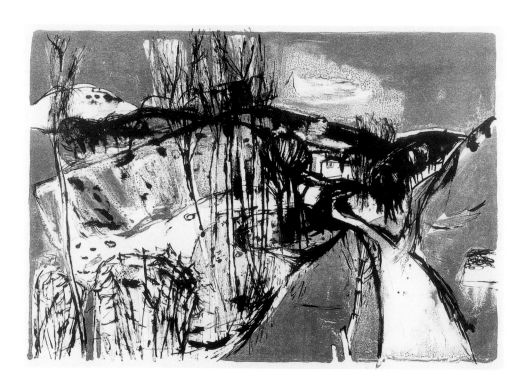

1 *Tuscan Landscape* 1958 Cat. 1
Lithograph: 43.5 x 63.5 cm (17⅛ x 25 in)

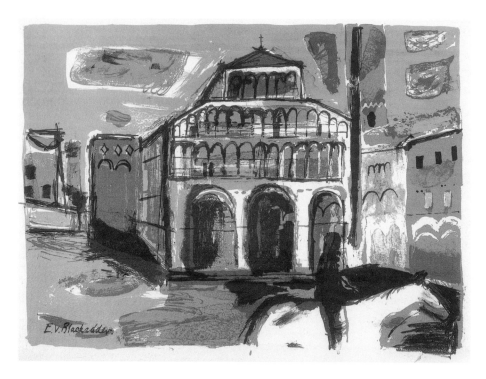

2 *San Martino, Lucca* 1958 Cat. 3
Lithograph: 21.7 x 30.7 cm (8½ x 12⅛ in)

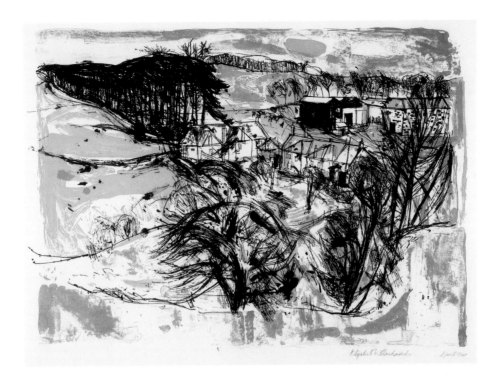

3 *Fifeshire Farm* 1960 Cat. 4
Lithograph: 47.6 x 67.6 cm (18¾ x 26⅝ in)

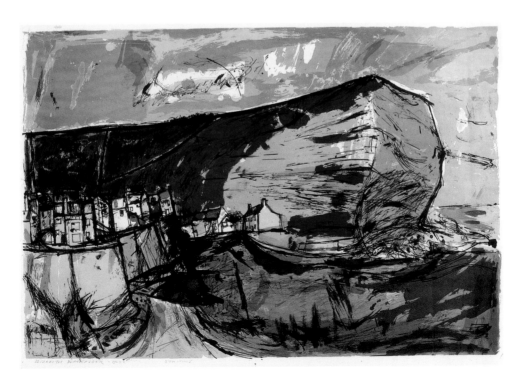

4 *Staithes* 1962 Cat. 6
Lithograph: 52.1 x 78.7 cm (20½ x 31 in)

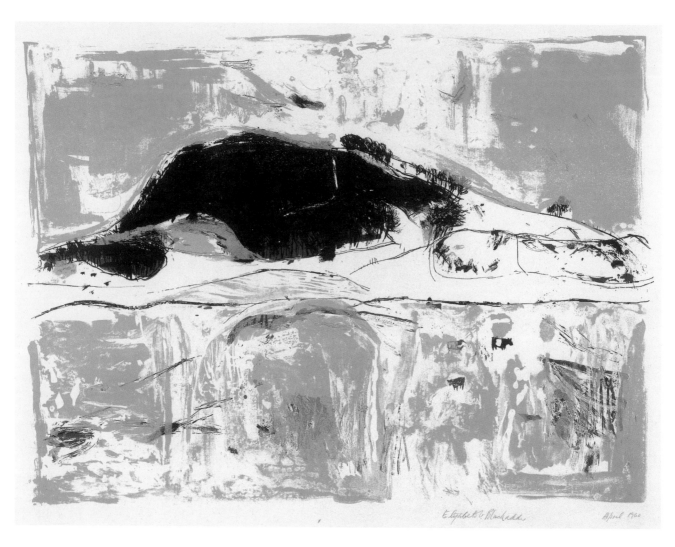

5 *Dark Hill, Fifeshire* 1960 Cat. 5
Lithograph: 47.9 x 66.7 cm (18⅞ x 26¼ in)

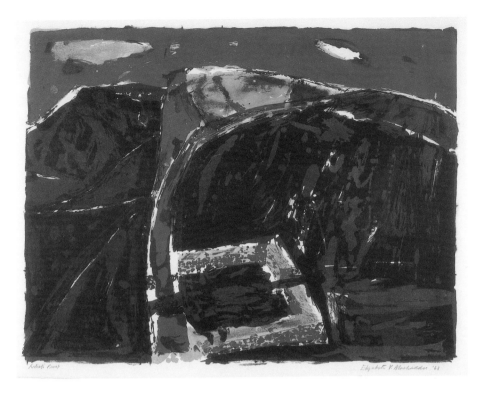

6 *Roman Wall I: Castle Nick* 1963 Cat. 7
Lithograph: 53.7 x 71.1 cm (21⅛ x 28 in)

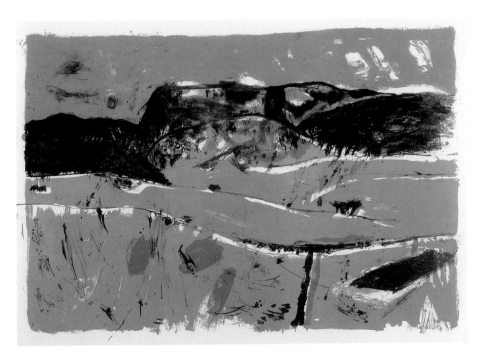

7 *Roman Wall II: Walltown* 1963 Cat. 8
Lithograph: 48.9 x 72.1 cm (19¼ x 28⅜ in)

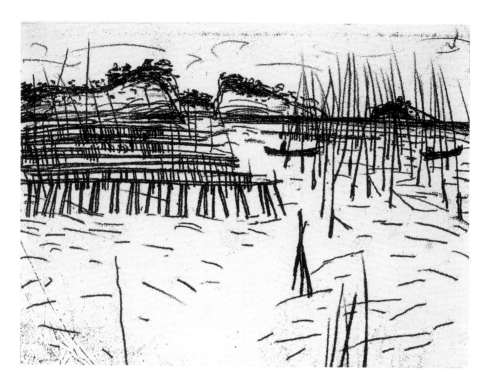

8 *Landscape in Japan* 1985 Cat. 16
Etching: 13.0 x 17.8 cm (5⅛ x 7 in)

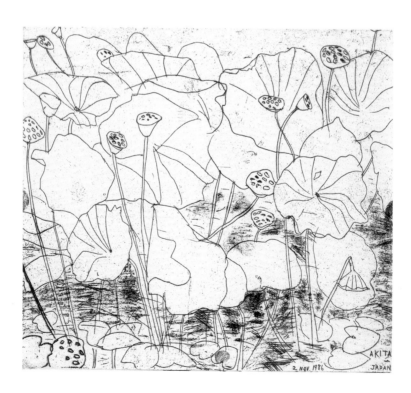

9 *Lotus Pond – Akita* 1987 Cat. 26
Etching: 22.4 x 25.0 cm (8¾ x 9⅞ in)

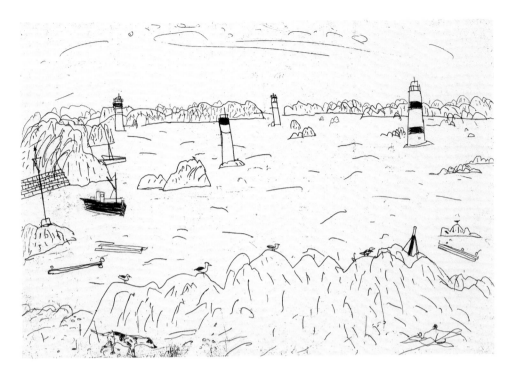

10 *Loguivy de la Mer, Brittany* 1987 Cat. 27
Etching: 19.5 x 28.2 cm (7¾ x 11 in)

11 *Japanese Garden, Kyoto* 1992 Cat. 55
Etching and aquatint: 14.2 x 20.0 cm (5⅝ x 7⅞ in)

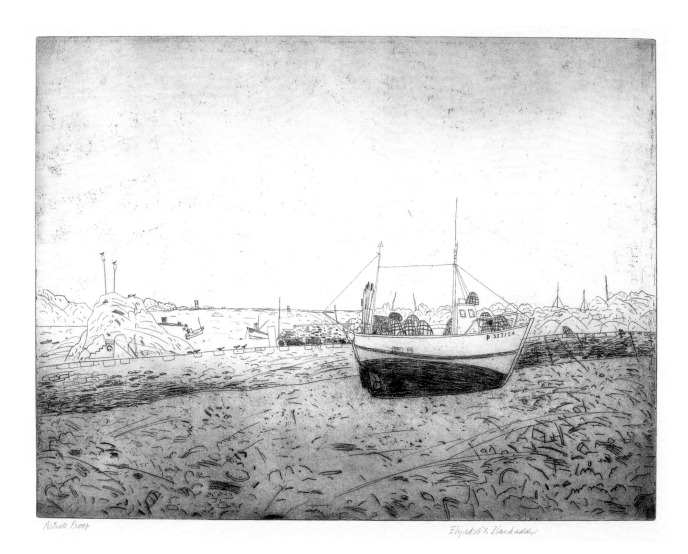

Elizabeth V. Blackadder

12 *Fishing Boats at Loguivy* 1992 Cat. 59
Etching: 45.5 x 60.7 cm (17⅞ x 23⅞ in)

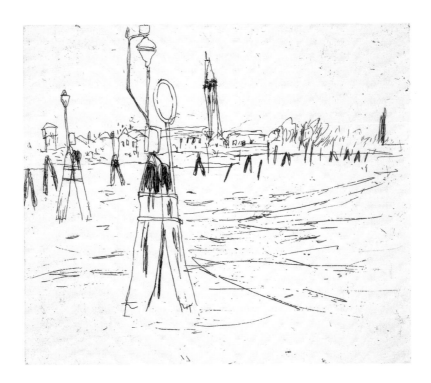

13 *Burano* 1997–8 Cat. 88
Etching: 15.0 x 17.5 cm (5⅞ x 6⅞ in)

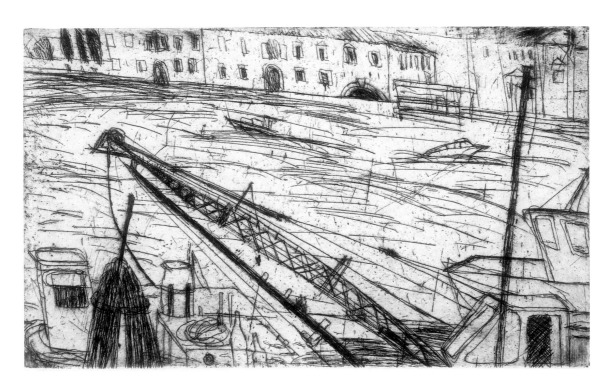

14 *Venice: High Tide* 2000 Cat. 101
Etching: 10.0 x 17.5 cm (4 x 6⅞ in)

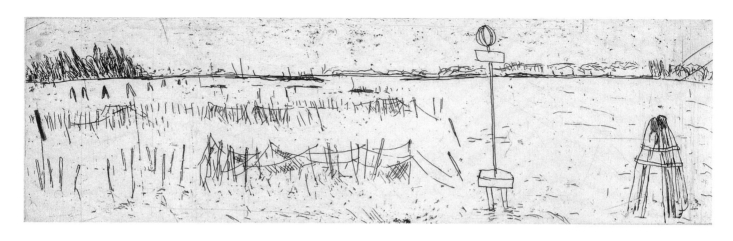

15 *Fishing Nets, Burano* 1997–8 Cat. 89
Etching: 8.8 x 30.0 cm (3½ x 11¾ in)

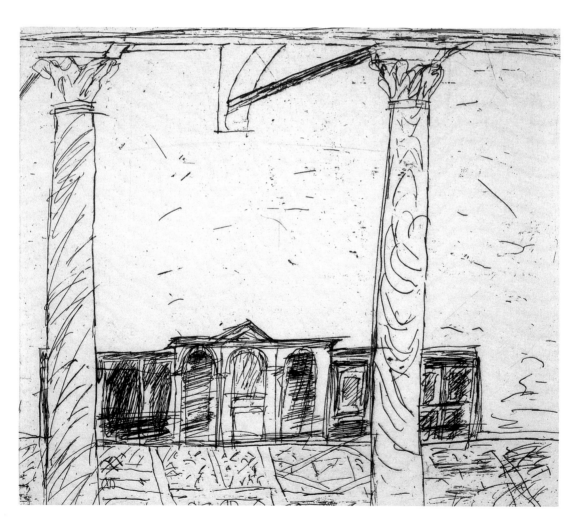

16 *Torcello* 1997–8 Cat. 91
Etching: 15.0 x 17.6 cm (5⅞ x 7 in)

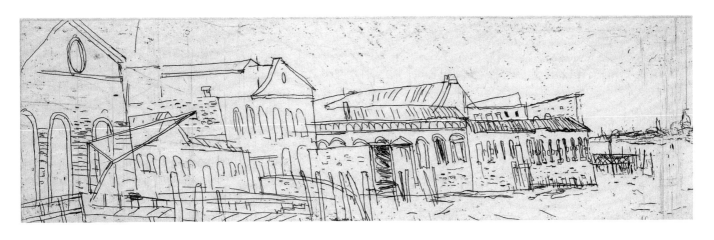

17 *Murano* 1997–8 Cat. 90
Etching: 8.8 x 30.0 cm (3½ x 11¾ in)

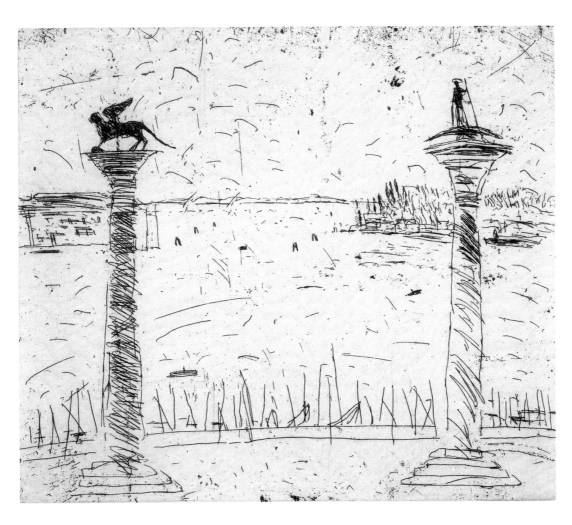

18 *Piazzetta* 1997–8 Cat. 92
Etching: 15.2 x 17.7 cm (6 x 7 in)

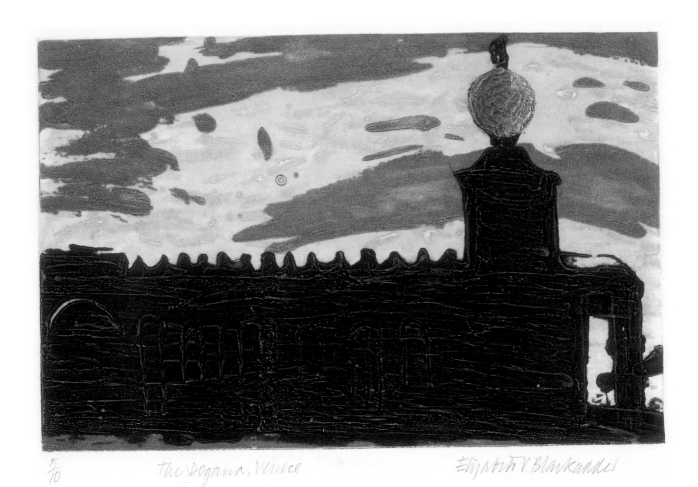

The Dogana, Venice Elizabeth V. Blackadder

19 *Dogana, Venice* 1999–2000 Cat. 98
Carborundum: 18.2 x 28.5 cm (7⅛ x 11¼ in)

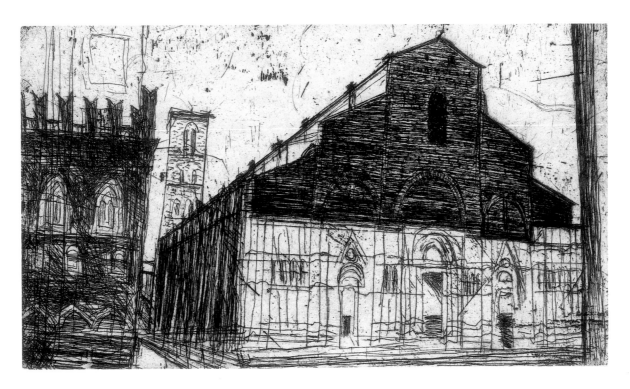

20 *Basilica San Petronio, Bologna* 2000 Cat. 102
Etching: 10.0 x 17.5 cm (4 x 6⅞ in)

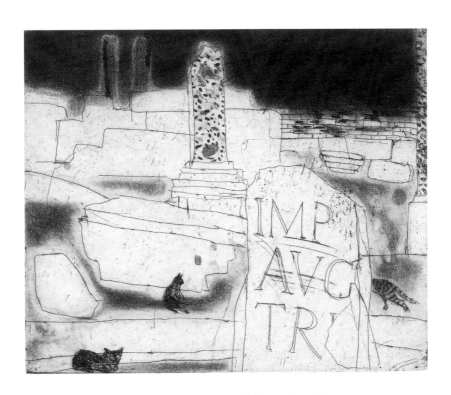

21 *The Forum, Rome* 2000–1 Cat. 107
Etching and aquatint: 14.7 x 17.8 cm (5¾ x 7 in)

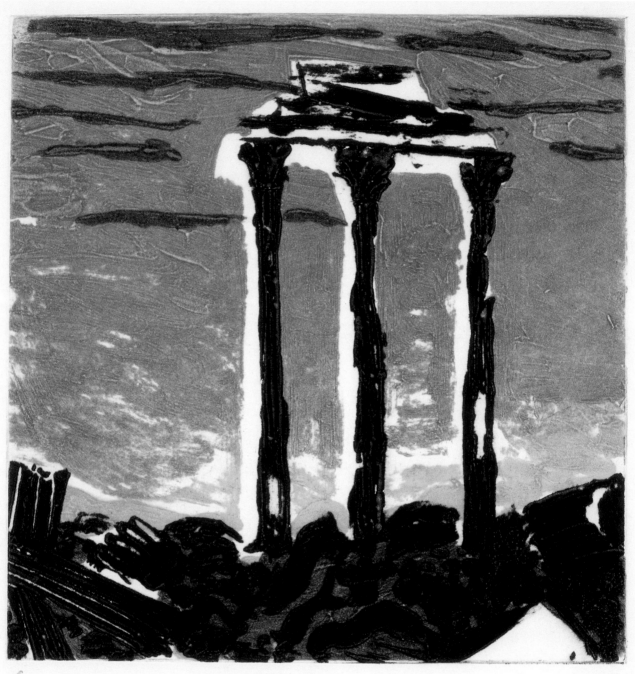

$\frac{9}{70}$ *Tempio dei Castori, Rome* Elizabeth V. Blackadder

22 *Tempio dei Castori, Rome* 1999–2000 Cat. 97
Carborundum: 19.0 x 18.7 cm (7½ x 7⅜ in)

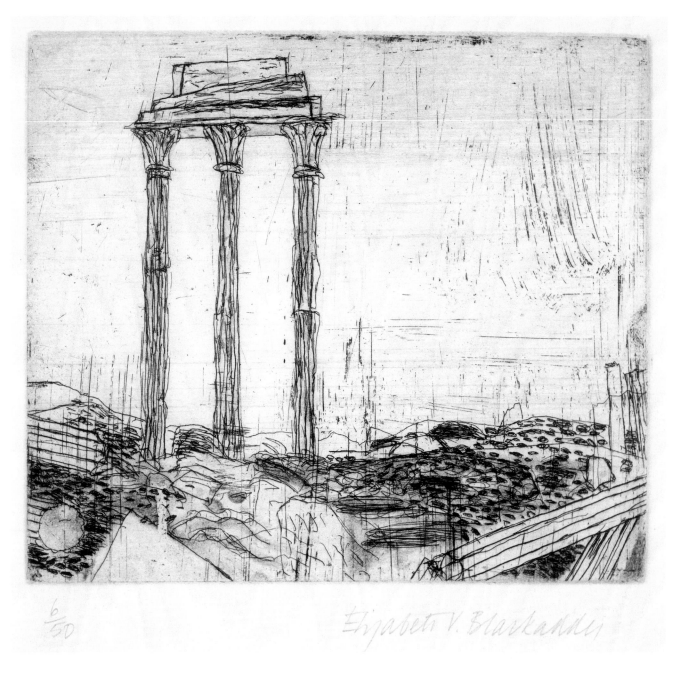

6/50

Elizabeth V. Blackadder

23 *Tempio dei Castori* 2000–1 Cat. 108
Etching and aquatint: 15.3 x 18.0 cm (6 x 7⅛ in)

Still lifes and interiors

24 *Harlequin* 1958 Cat. 2
Lithograph: 27.8 x 45.5 cm (11 x 18 in)

25 *Cats and Flowers* 1979–80 Cat. 10
Lithograph: 58.0 x 79.0 cm (22¾ x 31⅛ in)

26 *Still Life with Wooden Puzzles* 1983 Cat. 13
Screenprint and lithograph: 46.0 x 58.5 cm (18⅛ x 23 in)

27 *Japanese Still Life* 1986 Cat. 21
Etching and aquatint: 60.4 x 81.9 cm (23¾ x 32¼ in)

28 *Still Life and Fan* 1979–80 Cat. 9
Lithograph: 59.0 x 81.0 cm (23¼ x 32 in)

29 *Still Life with Indian Toy* 1982 Cat. 11
Lithograph: 46.2 x 58.5 cm (18¼ x 23 in)

Above left:
30 *Beetles and Flower Heads* 1986 Cat. 20
Etching: 25.0 x 15.2 cm (9⅞ x 6 in)

Above right:
31 *Japanese Table* 1987 Cat. 24
Etchings: each 10.2 x 15.2 cm (4 x 6 in)

Left:
32 *Indian Still Life* 1987 Cat. 22
Etching: 30.3 x 22.8 cm (12 x 9 in)

IV/V Artists Proof Elizabeth Blackadder

33 *Indian Still Life (Colour)* 1987 Cat. 23
Etching and aquatint: 30.3 × 22.8 cm (12 × 9 in)

Artist's Proof Elizabeth V. Blackadder

34 *Parrots* 1987 Cat. 25
Etching and aquatint: 23.0 x 30.5 cm (9 x 12 in)

35 *Still Life with Iris* 1987–9 Cat. 38
Etching and aquatint: 43.0 x 53.2 cm (17 x 21 in)

36 *Little Kyoto Still Life* 1988 Cat. 39
Etching and aquatint: 15.2 x 21.5 cm (6 x 8½ in)

37 *Two Exotic Fruits* 1989 Cat. 44
Etching and aquatint: 22.9 x 28.0 cm (9 x 11 in)

38 *Little Doorway, Kyoto* 1989 Cat. 45
Etching and aquatint: 7.7 x 12.5 cm (3 x 5 in)

39 *Fortune Teller, Kyoto* 1989 Cat. 46
Etching and aquatint: 25.4 x 35.5 cm (10 x 14 in)

40 *Red Still Life* 1989 Cat. 48
Etching and aquatint: 20.3 x 25.4 cm (8 x 10 in)

41 *Still Life with Lily and Flute* 1990 Cat. 53
Etching and aquatint: 32.5 x 45.3 cm (12¾ x 17⅞ in)

Artist's Proof Eleanor Blackadder

42 *Konchi-in, Kyoto* 1992 Cat. 54
Etching and aquatint: 10.2 x 14.0 cm (4 x 5½ in)

43 *Autumn Kyoto* 1996 Cat. 81
Etching and aquatint: 18.0 x 152.0 cm (7⅛ x 59⅞ in)

26/30 Elizabeth Blackadder

44 *View of a Garden* 1996 Cat. 82
Etching and aquatint: 10.0 x 12.0 cm (4 x 4¾ in)

45 *Japanese Interior, Kyoto* 1999 Cat. 96
Carborundum: 43.8 x 54.4 cm (17¼ x 21⅜ in)

46 *Still Life with Pagoda* 1997 Cat. 87
Screenprint: 41.5 x 59.2 cm (16⅜ x 23¼ in)

47 *Still Life with Boxes* 2001 Cat. 109
Screenprint: 43.0 x 64.0 cm (17 x 25¼ in)

Animals

48 *Black Cat* 1982 Cat. 12
Lithograph: 40.0 x 57.5 cm (15¾ x 22⅝ in)

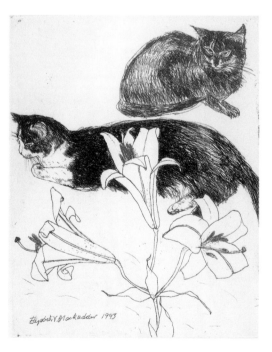

49 *Black Cat and Lily* 1988 Cat. 40
Etching and aquatint: 21.2 x 15.2 cm (8⅜ x 6 in)

50 *Cats and Lily* 1993 Cat. 72
Etching: 35.0 x 27.7 cm (13¾ x 11 in)

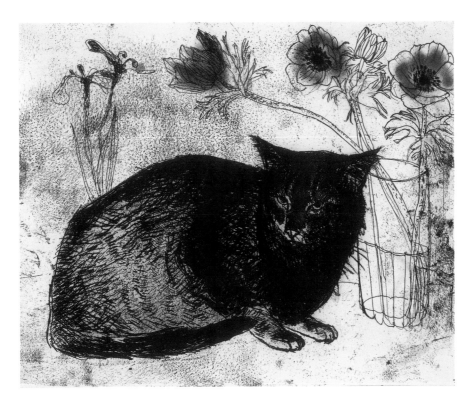

51 *Cat and Anemonies* 1989 Cat. 49
Etching and aquatint: 20.0 x 25.3 cm (7⅞ x 10 in)

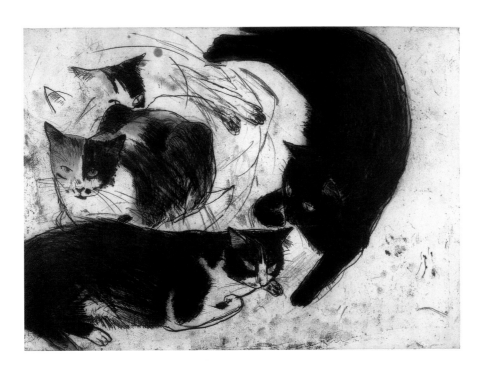

52 *Three Cats* 1992 Cat. 57
Etching and aquatint: 41.7 x 58.7 cm (16⅜ x 23⅛ in)

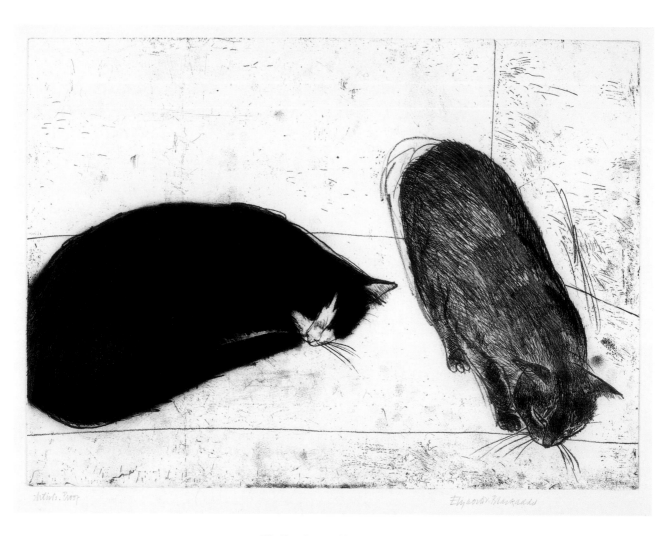

53 *Two Cats* 1992 Cat. 58
Etching and aquatint: 41.5 x 58.7 cm (16⅜ x 23⅛ in)

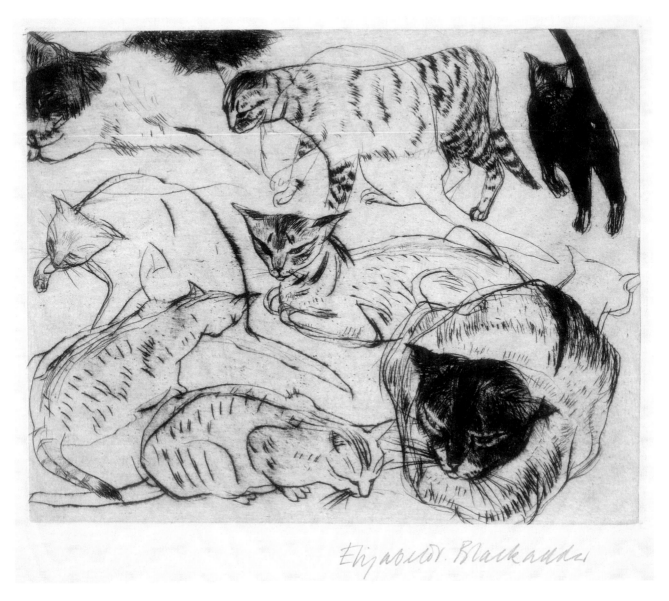

Elizabeth Blackadder

54 *Studies of Cats* 1995 Cat. 75
Drypoint: 15.0 x 19.5 cm (5⅞ x 7⅝ in)

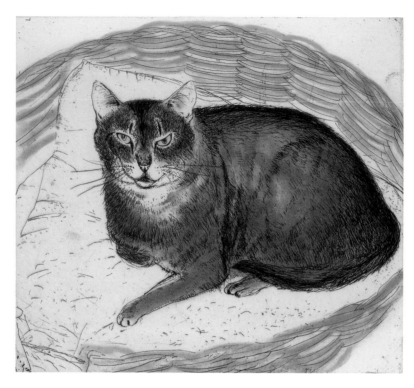

55 *Abyssinian Cat in a Basket* 1995 Cat. 78
Etching and aquatint: 23.0 x 25.5 cm (9 x 10 in)

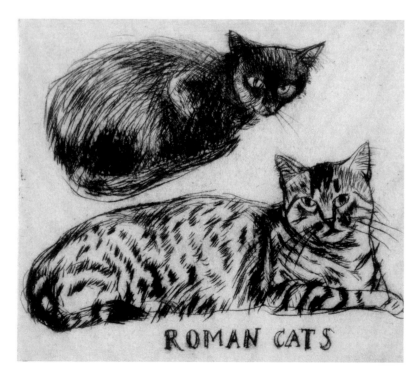

56 *Roman Cats* 1995 Cat. 76
Drypoint: 9.0 x 10.0 cm (3½ x 4 in)

'The Champion'

57 *The Champion* 1995 Cat. 80
Etching: 21.0 x 25.5 cm (8¼ x 10 in)

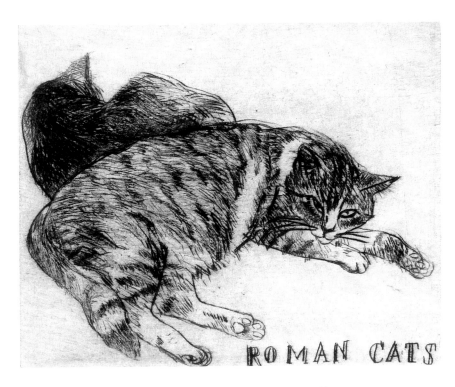

ROMAN CATS

58 *Roman Cats II* 1999–2000 Cat. 99
Drypoint: 8.0 x 10.0 cm (3⅛ x 4 in)

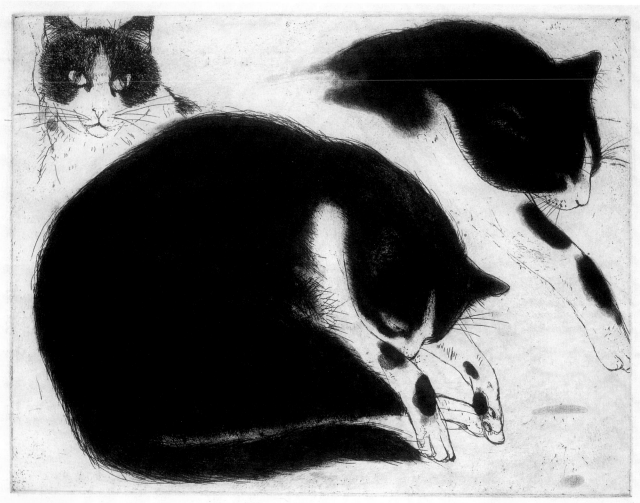

Artist's Proof

Elizabeth Blackadder

59 *Black and White Cat* 1995 Cat. 79
Etching and aquatint: 22.8 x 30.4 cm (9 x 12 in)

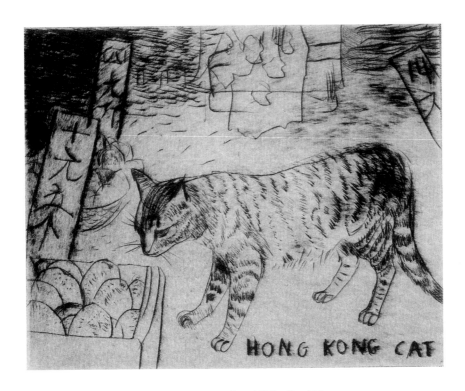

60 *Hong Kong Cat* 1995 Cat. 77
Drypoint: 8.0 x 10.0 cm (3⅛ x 4 in)

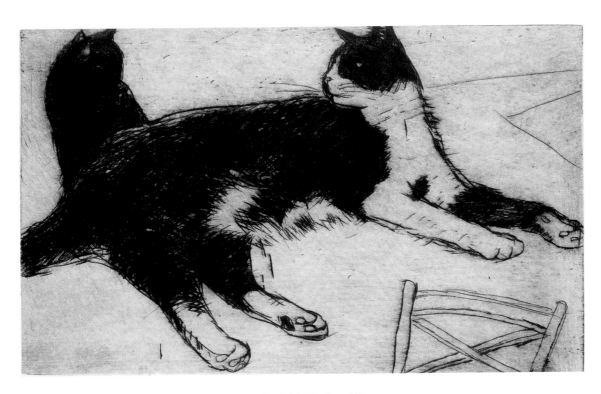

61 *Fred* 2000 Cat. 100
Drypoint: 8.5 x 14.0 cm (3⅜ x 5½ in)

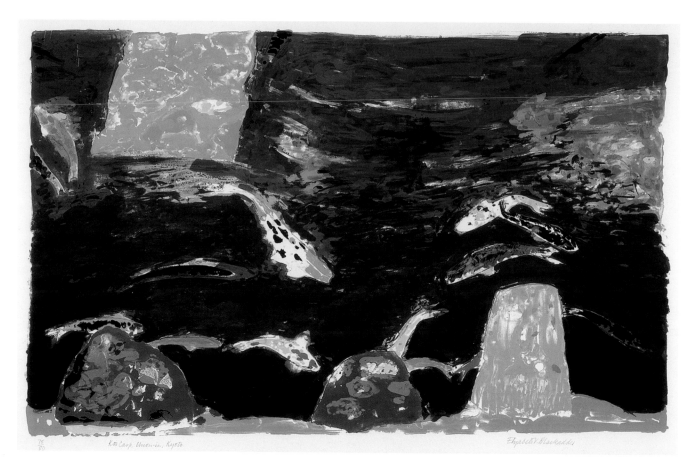

62 *Koi Carp, Chion-In* 1997 Cat. 84
Screenprint: 66.5 x 92.0 cm (26¼ x 36¼ in)

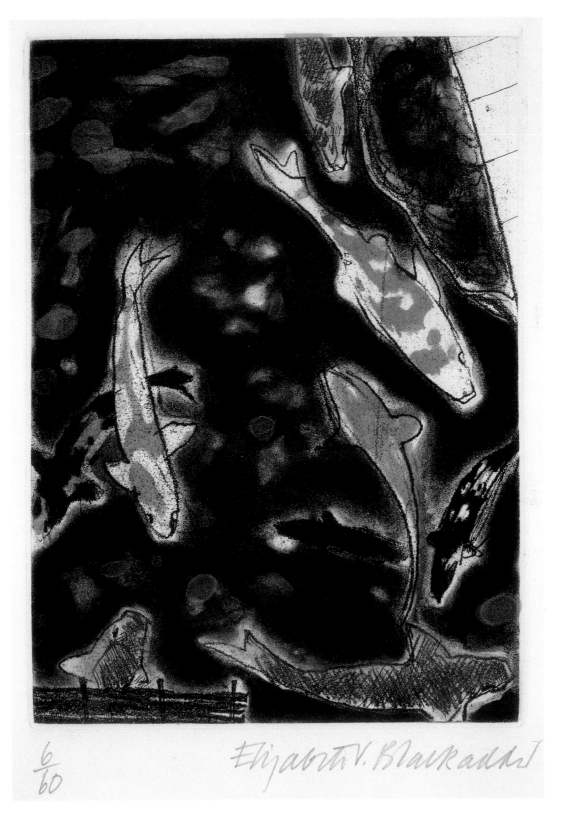

6/60

Elizabeth V. Blackadder

63 *Koi Carp* 1998–9 Cat. 93
Etching and aquatint: 17.0 x 12.5 cm (6⅞ x 4⅞ in)

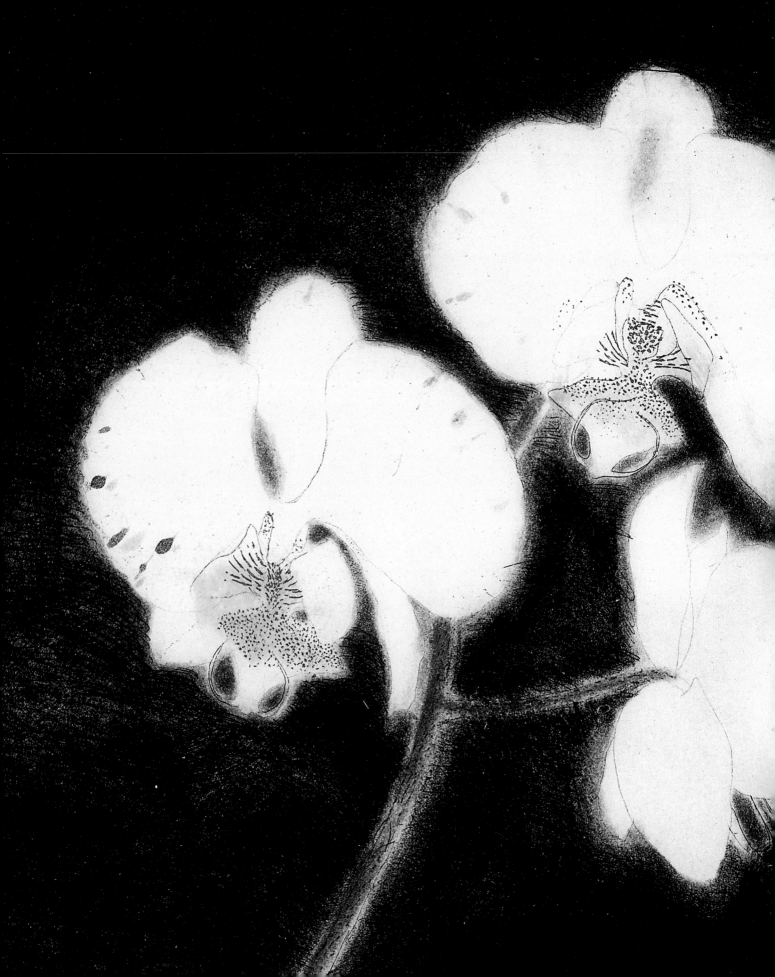

Orchids

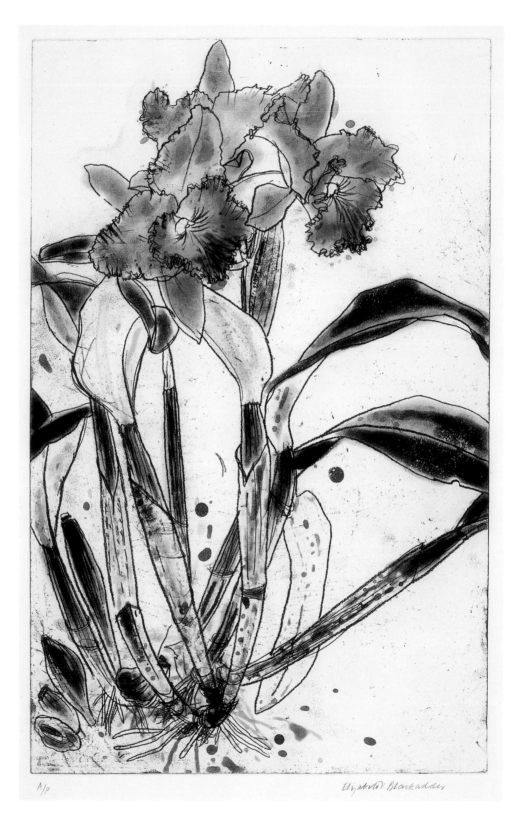

A/p Elizabeth Blackadder

64 *Orchid* 1985 Cat. 18
Etching and aquatint: 50.8 x 32.8 cm (20 x 12⅞ in)

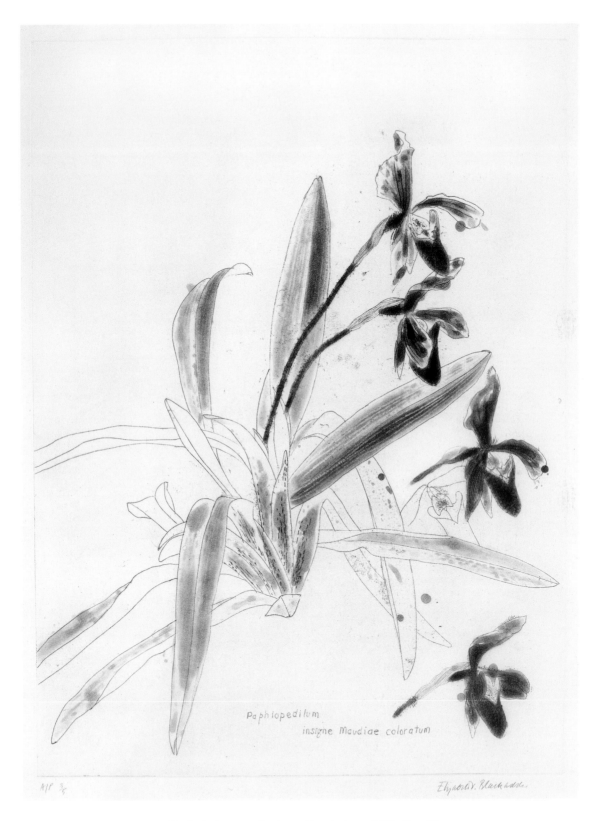

Paphiopedilum
insigne Maudiae coloratum

A/P ⅗ Elizabeth V. Blackadder

65 *Orchidaceae – Paphiopedilum insigne* 1987 Cat. 32
Etching and aquatint: 60.9 x 45.5 cm (24 x 18 in)

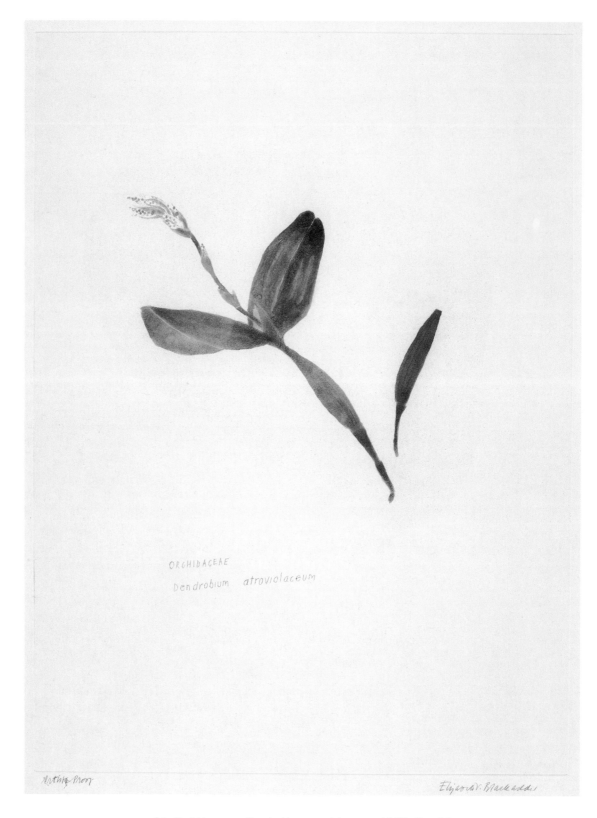

ORCHIDACEAE
Dendrobium atroviolaceum

66 *Orchidaceae – Dendrobium atroviolaceum* 1987 Cat. 29
Etching and aquatint: 60.8 x 45.4 cm (24 x 17⅞ in)

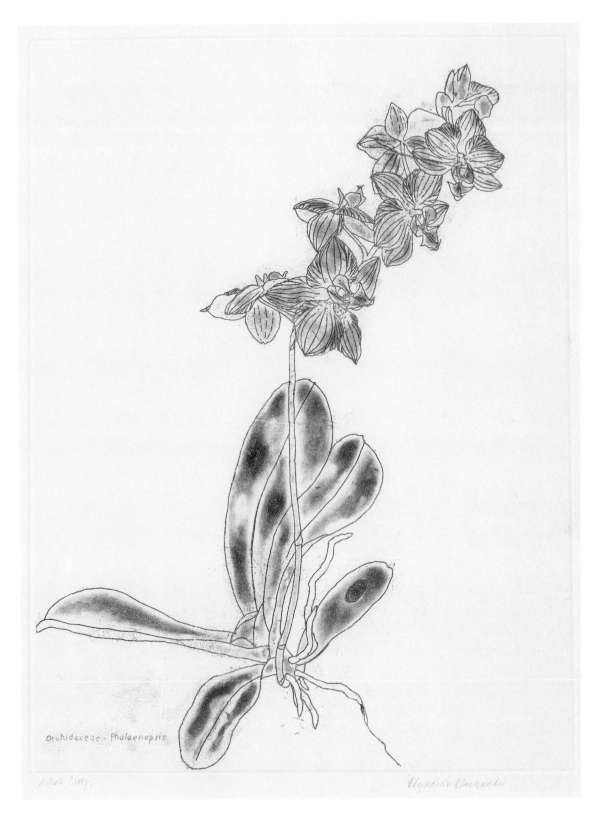

Orchidaceae - Phalaenopsis

67 *Orchidaceae – Phalaenopsis* 1987 Cat. 34
Etching and aquatint: 59.7 x 45.5 cm (23½ x 18 in)

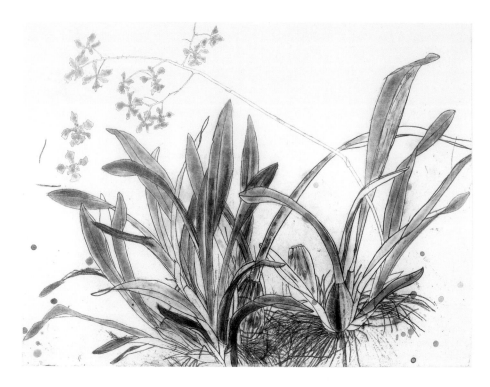

68 *Orchid Oncidium* 1987 Cat. 28
Etching and aquatint: 60.5 x 82.3 cm (23¾ x 32⅜ in)

69 *Orchidaceae – Masdevallia* 1987 Cat. 35
Etching: 60.9 x 45.5 cm (24 x 18 in)

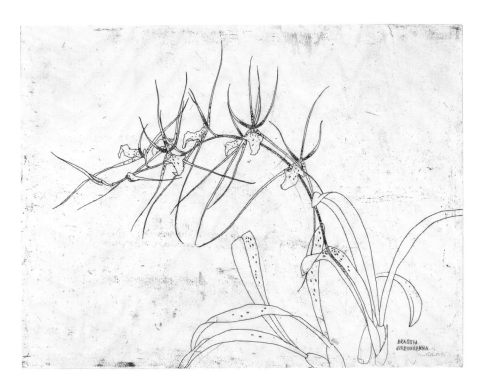

70 *Orchidaceae – Brassia gireoudiana I* 1987 Cat. 30
Etching: 45.3 x 60.5 cm (17⅞ x 23⅞ in)

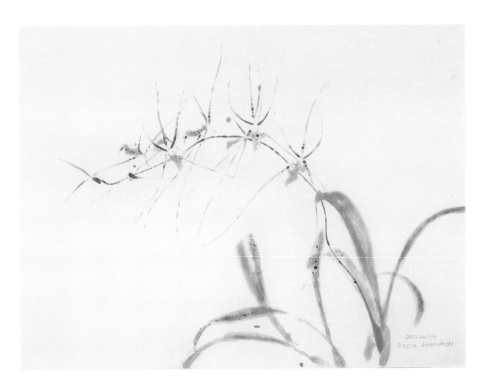

71 *Orchidaceae – Brassia gireoudiana II* 1987 Cat. 31
Aquatint: 45.3 x 60.8 cm (17⅞ x 24 in)

72 *Orchidaceae – Bulbophyllum rothschildianum* 1987 Cat. 33
Etching and aquatint: 44.5 x 60.8 cm (17½ x 24 in)

73 *Little Orchid* 1988–9 Cat. 41
Etching and aquatint: 20.3 x 15.2 cm (8 x 6 in)

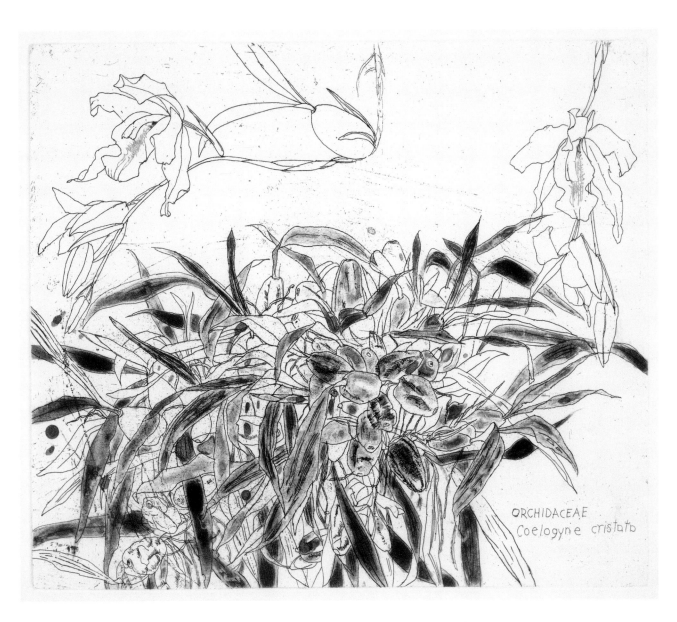

ORCHIDACEAE
Coelogyne cristata

74 *Orchidaceae – Coelogyne cristata* 1992 Cat. 60
Etching and aquatint: 30.5 x 35.5 cm (12 x 14 in)

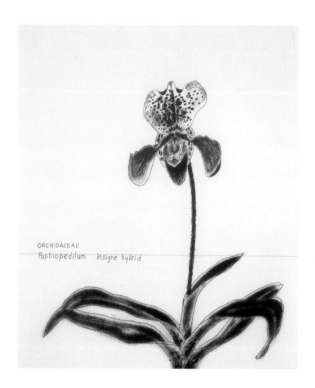

75 *Orchid Portfolio 1. Paphiopedilum insigne hybrid* 1991–3 Cat. 61
Etching and aquatint: 35.5 x 30.5 cm (14 x 12 in)

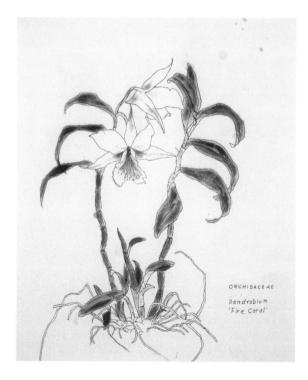

76 *Orchid Portfolio 2. Dendrobium 'Fire Coral'* 1991–3 Cat. 62
Etching and aquatint: 35.5 x 30.5 cm (14 x 12 in)

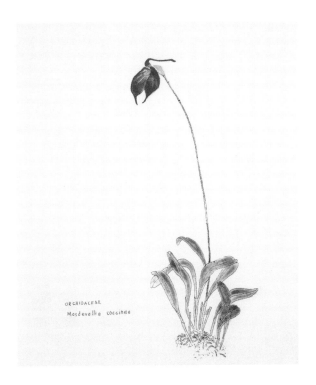

77 *Orchid Portfolio 3. Masdevallia coccinea* 1991–3 Cat. 63
Etching and aquatint: 35.5 x 30.5 cm (14 x 12 in)

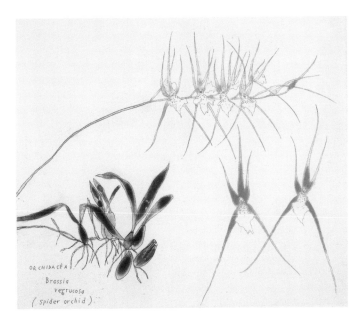

78 *Orchid Portfolio 4. Brassia verrucosa* 1991–3 Cat. 64
Etching and aquatint: 30.5 x 35.5 cm (12 x 14 in)

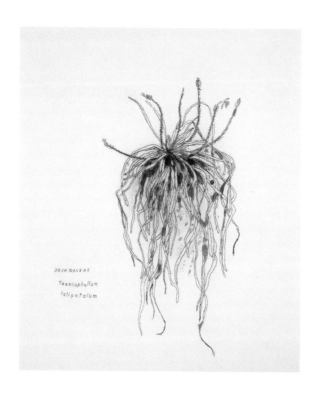

79 *Orchid Portfolio 5. Taeniophyllum latipetalum* 1992–3 Cat. 65
Etching and aquatint: 35.5 x 30.5 cm (14 x 12 in)

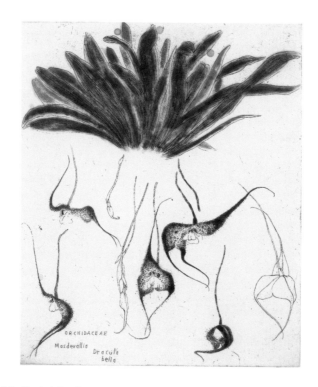

80 *Orchid Portfolio 6. Masdevallia dracula bella* 1992–3 Cat. 66
Etching and aquatint: 35.5 x 30.5 cm (14 x 12 in)

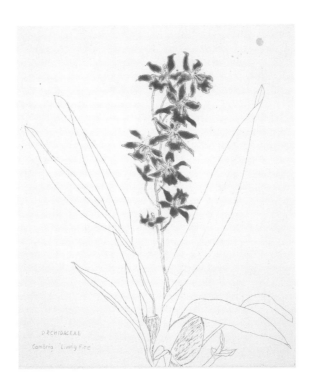

81 *Orchid Portfolio 7. Cambria 'Living Fire'* 1991–3 Cat. 67
Etching and aquatint: 35.5 x 30.5 cm (14 x 12 in)

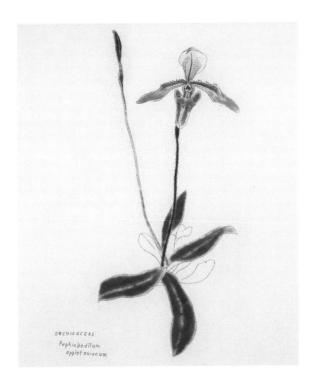

82 *Orchid Portfolio 8. Paphiopedilum appletonianum* 1991–3 Cat. 68
Etching and aquatint: 35.5 x 30.5 cm (14 x 12 in)

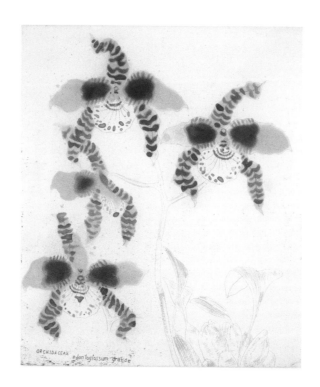

83 *Orchid Portfolio 9. Odontoglossum grande* 1991–3 Cat. 69
Etching and aquatint: 35.5 x 30.5 cm (14 x 12 in)

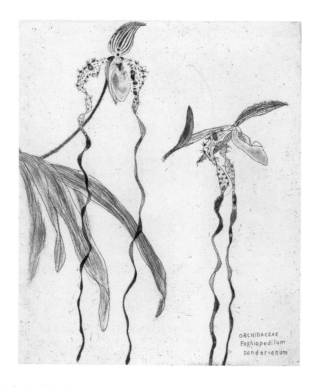

84 *Orchid Portfolio 10. Paphiopedilum sanderianum* 1991–3 Cat. 70
Etching and aquatint: 35.5 x 30.5 cm (14 x 12 in)

Artist's Proof Elizabeth V. Blackadder

85 *Orchidaceae – Phalaenopsis antarctica* 1993 Cat. 71
Etching and aquatint: 30.2 x 35.5 cm (12 x 14 in)

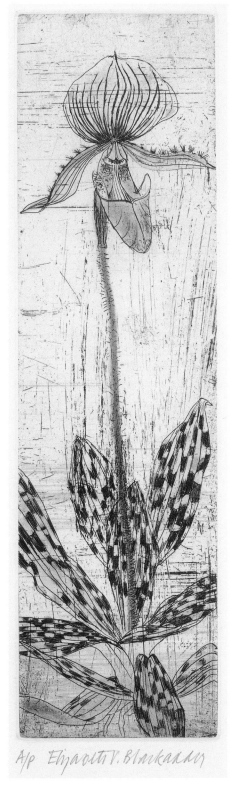

A/p Elizabeth V. Blackadder

86 *Orchid Paphiopedilum* 2000 Cat. 103
Etching and aquatint: 30.0 x 8.8 cm (11¾ x 3½ in)

87 *Orchidaceae – Coelogyne cristata* 1999 Cat. 95
Aquatint and carborundum: 44.0 x 54.5 cm (17⅜ x 21½ in)

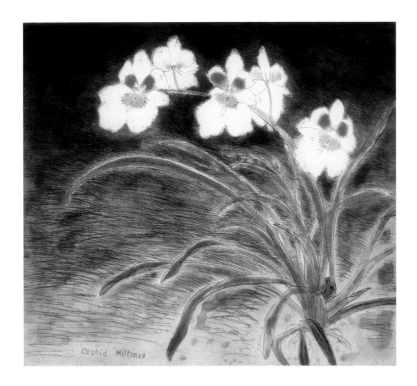

88 *Orchid Miltonia No. I* 2000 Cat. 104
Etching and aquatint: 38.0 x 43.0 cm (15 x 17 in)

89 *Orchid Miltonia No. II* 2000–1 Cat. 105
Etching and aquatint: 38.0 x 43.0 cm (15 x 17 in)

Other plant studies

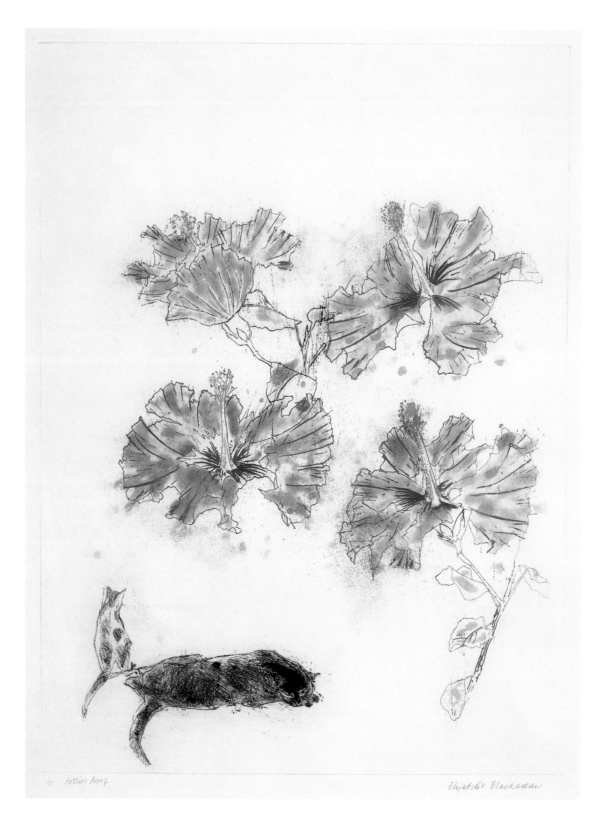

90 *Hibiscus and Cats* 1985 Cat. 14
Etching and aquatint: 61.0 x 45.7 cm (24 x 18 in)

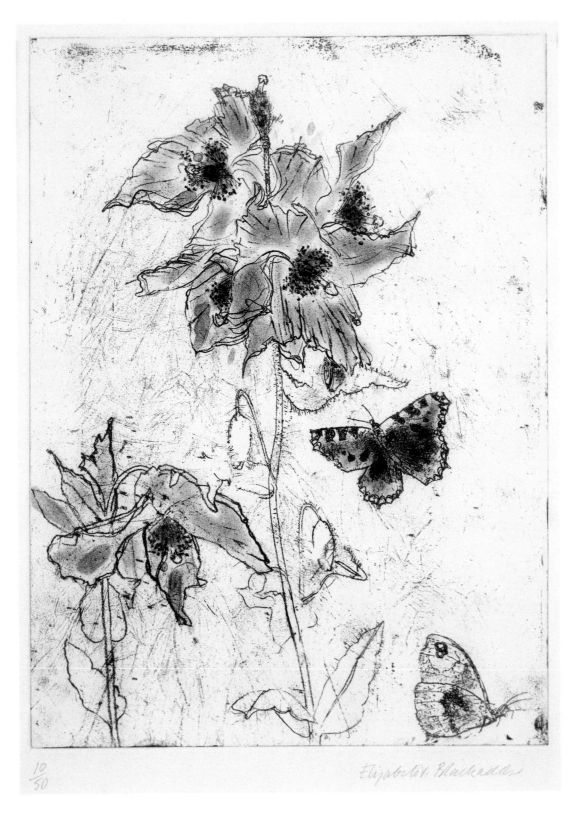

10/50 Elizabeth Blackadder

91 *Meconopsis and Butterflies* 1985 Cat. 17
Etching and aquatint: 30.1 x 22.7 cm (11⅞ x 9 in)

92 *Flower* 1985 Cat. 19
Etching and aquatint: 17.5 x 13.2 cm (6⅞ x 5¼ in)

93 *Iris* 1985–6 Cat. 19
Etching: 19.0 x 24.0 cm (7½ x 9½ in)

94 *Banksia* 1989 Cat. 43
Etching and aquatint: 15.2 x 20.2 cm (6 x 8 in)

95 *Lilies* 1989 Cat. 51
Woodcut: 61.0 x 45.7 cm (24 x 18 in)

Tillandsia

96 *Tillandsia* 1987 Cat. 36
Etching and aquatint: 59.8 × 60.2 cm (23½ × 23¾ in)

Artists Proof Elizabeth Blackadder

97 *Black Iris* 1989 Cat. 42
Etching and aquatint: 17.8 x 13.3 cm (7 x 5¼ in)

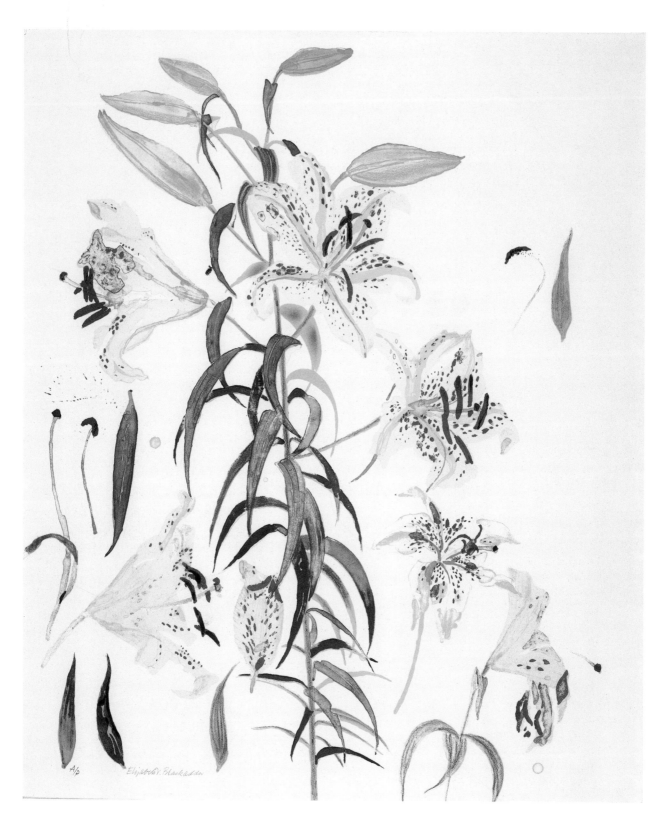

98 *Auratum Lily* 1987 Cat. 37
Lithograph: 67.0 x 56.5 cm (26⅜ x 22¼ in)

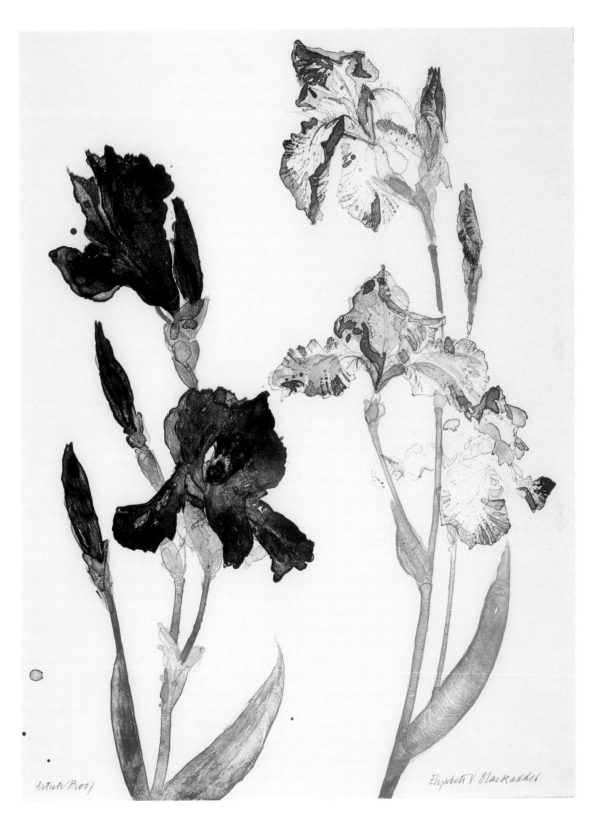

artists Proof Elizabeth V. Blackadder

99 *Irises* 1989 Cat. 47
Lithograph: 61.0 x 45.8 cm (24 x 18 in)

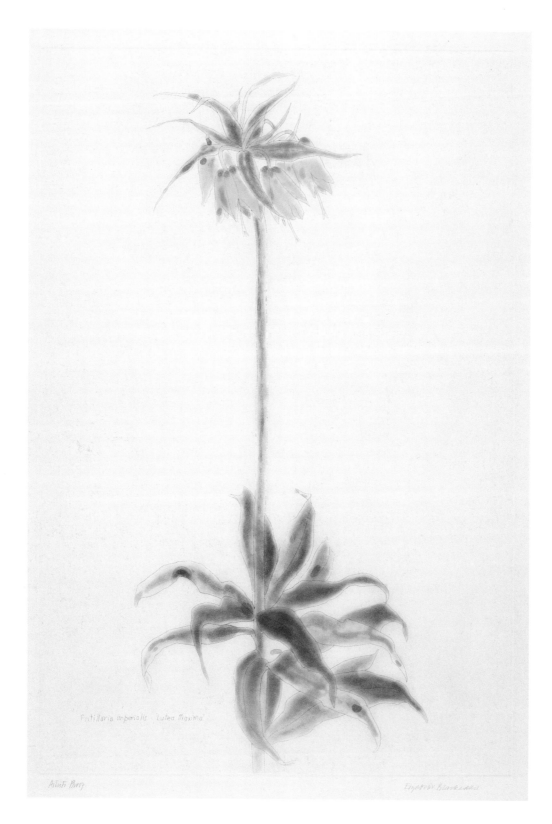

100 *Fritillaria imperialis* 1989 Cat. 50
Etching and aquatint: 75.8 x 51.0 cm (29⅞ x 20⅛ in)

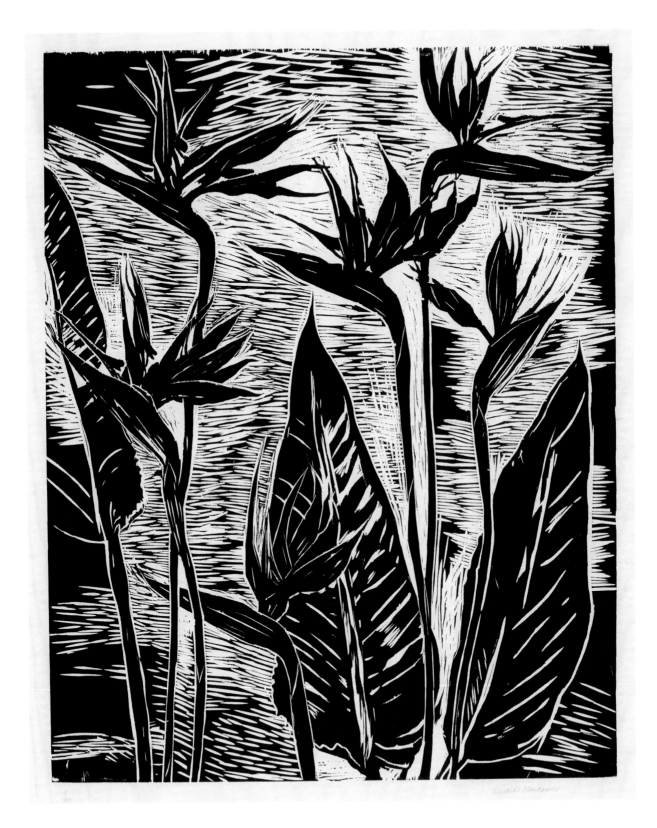

101 *Strelitzia* 1989 Cat. 52
Woodcut: 76.1 x 61.0 cm (30 x 24 in)

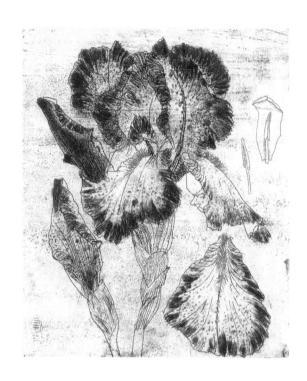

102 *Blue Iris* 1992 Cat. 56
Etching and aquatint: 24.0 x 20.2 cm (9½ x 8 in)

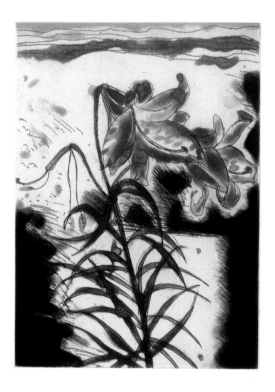

103 *The Lily* 1998–9 Cat. 94
Etching and aquatint: 17.0 x 12.5 cm (6⅞ x 4⅞ in)

104 *Irises* 1994 Cat. 73
Etching and aquatint: 14.0 x 17.3 cm (5½ x 6¾ in)

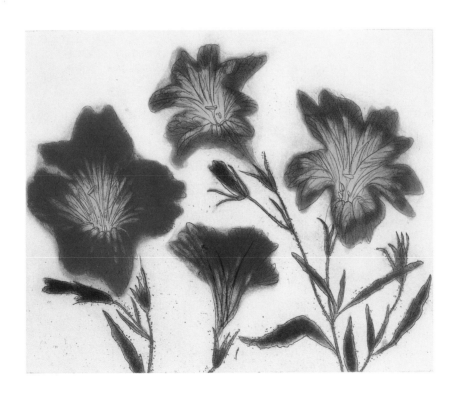

105 *Salpiglossis* 1994 Cat. 74
Etching and aquatint: 14.0 x 17.3 cm (5½ x 6¾ in)

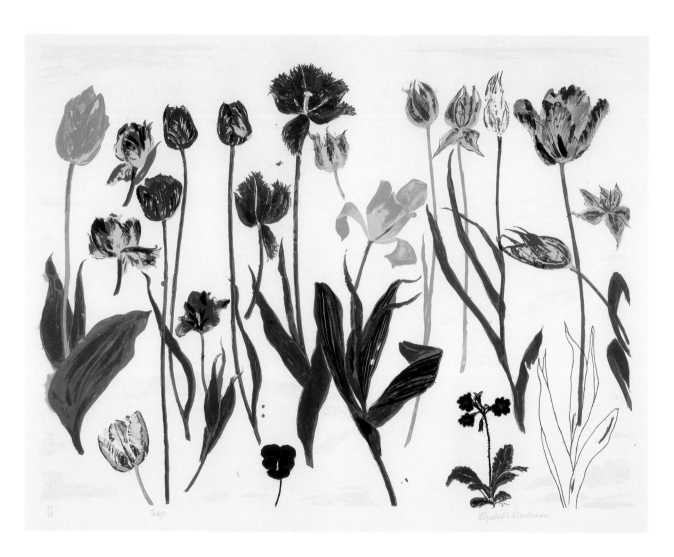

106 *Tulips* 1997 Cat. 85
Screenprint: 58.0 x 77.0 cm (22⅞ x 30¼ in)

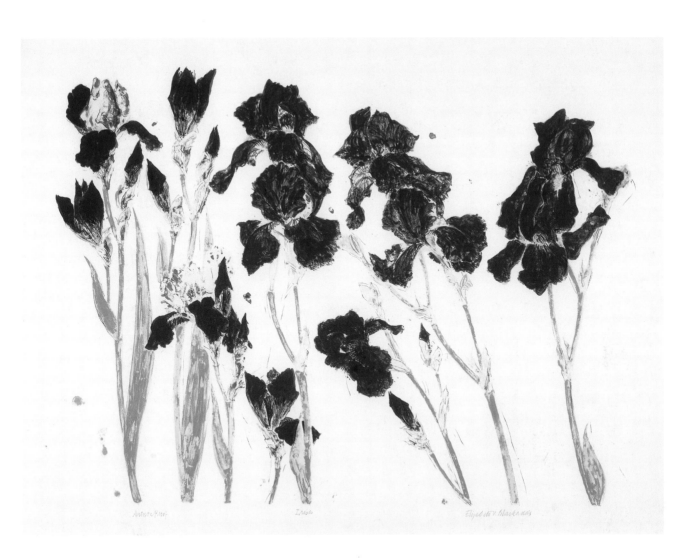

107 *Irises* 1997 Cat. 86
Screenprint: 58.0 x 80.5 cm (22⅞ x 31¾ in)

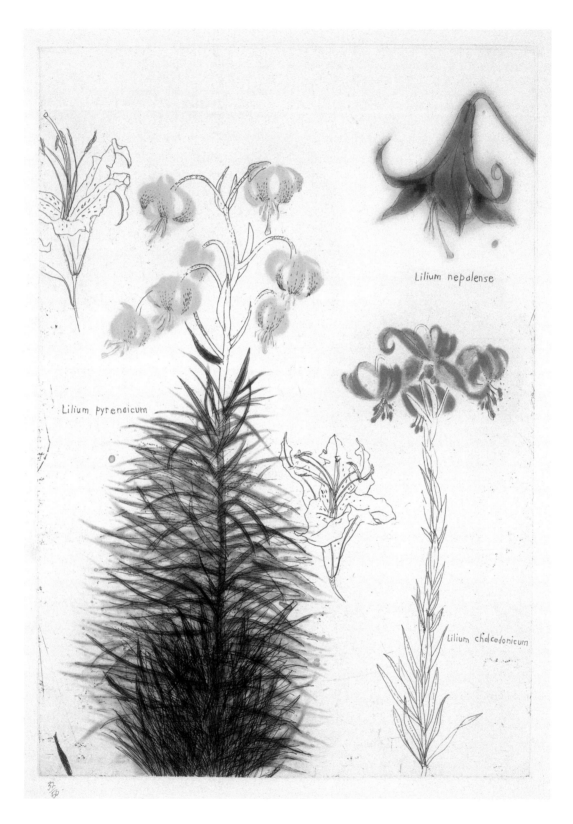

Lilium nepalense

Lilium pyrenaicum

Lilium chalcedonicum

108 *Lilium* 1997 Cat. 83
Etching and aquatint: 50.0 x 35.0 cm (19¾ x 13¾ in)

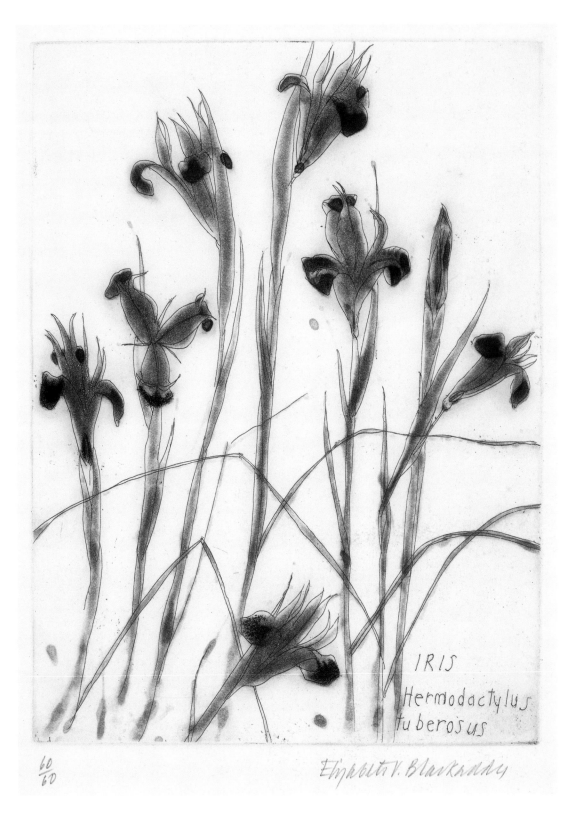

IRIS

Hermodactylus
tuberosus

60/60

Elizabeth V. Blackadder

109 *Iris – Hermodactylus tuberosus* 2000–1 Cat. 106
Etching and aquatint: 32.0 x 24.0 cm (12⅝ x 9½ in)

Catalogue of published prints

This summary catalogue is arranged in the best chronological order that the artist, her printers and her dealer can recall, and with reference to extant records. The artist has not normally dated her prints in the plate or when signing editions. Where more than one year is given for the date, the first represents the date of inception and the second the date of publication. Where kindred groups (eg many of the Orchids) were made during one year they are grouped together.

Information on working proofs, artist's proofs, printer's proofs, archive proofs *etc* has been omitted. Normally, artist's proofs may be assumed to be not more than 10 per cent over the given edition size (eg five proofs for an edition of fifty) with, in addition, one *bon à tirer*, two printer's proofs, one *hors commerce* and one archive proof. Early in the artist's career quantities of such proofs were even smaller. Where the printer and the publisher are separate, the printer's name is given first. A note about any abnormal circumstances bearing on the editioning of a print follows the relevant entry. Height precedes width in all measurements. Imperial measurements are given to the nearest ⅛ in. A '?' preceding any part of an entry means that, appropriate enquiries having proved negative, the information provided is a best guess.

1 *Tuscan Landscape* 1958 Pl. 1
Lithograph on plate and stone
I: violet; II: black
43.5 x 63.5 cm (17⅛ x 25 in):
Crisbrook waterleaf *c.* 300 gsm;
53.0 x 73.5 cm (20⅞ x 29 in)
Edition of 50, Harley Brothers, Edinburgh

2 *Harlequin* 1958 Pl. 24
Lithograph on three stones
I: red; II: green; III: yellow
27.8 x 45.5 cm (11 x 18 in):
Crisbrook waterleaf *c.* 300 gsm;
36.0 x 53.9 cm (14⅛ x 21¼ in)
Edition of 75, Harley Brothers, Edinburgh

3 *San Martino, Lucca* 1958 Pl. 2
Lithograph on three plates
I: black; II: grey; III: sienna
21.7 x 30.7 cm (8½ x 12⅛ in):
Crisbrook waterleaf *c.* 300 gsm;
30.3 x 46.7 cm (12 x 18⅜ in)
Edition of 70, Harley Brothers, Edinburgh
Note: edition not numbered; signed in the plate.

4 *Fifeshire Farm* 1960 Pl. 3
Lithograph on three stones
I: yellow; II: black, III: umber
47.6 x 67.6 cm (18¾ x 26⅝ in):
Crisbrook waterleaf *c.* 300 gsm;
58.0 x 80.5 cm (22⅞ x 31¾ in)
Edition of ?50, Curwen Studio, St George's
Gallery Prints, London

5 *Dark Hill, Fifeshire* 1960 Pl. 5
Lithograph on three stones
I: burnt sienna; II: black; III: pale warm grey
47.9 x 66.7 cm (18⅞ x 26¼ in):
Crisbrook waterleaf *c.* 300 gsm;
58.0 x 80.3 cm (22⅞ x 31⅝ in)
Edition of ?50, Curwen Studio, The Junior
Council of the Museum of Modern Art,
New York

6 *Staithes* 1962 Pl. 4
Lithograph on eight plates
Order unknown: black, light ochre, dark ochre,
mauve-purple, pale warm grey, pale blue-grey,
dark blue-grey, orange-red
52.1 x 78.7 cm (20½ x 31 in):
Mill finished machine paper;

73.5 x 92.0 cm (29 x 36¼ in)
Edition of approx. 1,600, Curwen Press,
General Post Office, London
Note: the edition was an unsigned run.
It is possible that an edition of up to 100,
on Crisbrook c. 300 gsm,
approx. 57.0 x 80.5 cm (22⅜ x 31¾ in),
omitting lettering and border, was also
printed but never signed nor published,
due to Crown copyright restrictions.

7 *Roman Wall I: Castle Nick* 1963 Pl. 6
Lithograph on three stones
I: brown; II: light blue-grey; III: deep green
53.7 x 71.1 cm (21⅛ x 28 in):
Crisbrook waterleaf c. 300 gsm;
57.5 x 80.5 cm (22⅝ x 31¼ in)
Edition of 50, Curwen Studio, St George's
Gallery Prints, London

8 *Roman Wall II: Walltown* 1963 Pl. 7
Lithograph on three stones
I: pink-brown; II: black; III: deep yellow ochre
48.9 x 72.1 cm (19¼ x 28⅜ in):
Crisbrook waterleaf c. 300 gsm;
57.0 x 80.5 cm (22½ x 31¼ in)
Edition of 50, Curwen Studio, St George's
Gallery Prints, London

9 *Still Life and Fan* 1979–80 Pl. 28
Lithograph on eight plates
I: blue-grey; II: beige-grey; III: pink; IV: green;
V: turquoise; VI: yellow; VII: red; VIII: black
59.0 x 81.0 cm (23¼ x 32 in):
BFK Rives blanc 300 gsm;
62.5 x 85.0 cm (24⅝ x 33½ in)
Edition of 75, Senefelder Press,
Mercury Gallery, London

10 *Cats and Flowers* 1979–80 Pl. 25
Lithograph on six plates
I: pale grey; II: grey; III: green; IV: mauve;
V: ochre; VI: dark brown
58.0 x 79.0 cm (22¾ x 31⅛ in):
Velin Arches blanc 275 gsm;
62.0 x 83.0 cm (24½ x 32¾ in)
Edition of 75, Senefelder Press,
Mercury Gallery, London

11 *Still Life with Indian Toy* 1982 Pl. 29
Lithograph on four stones/plates
Order unknown: beige, pink, black, gold
(plus paper tone and pale and dark bark)
46.2 x 58.5 cm (18¼ x 23 in):
Yamato Chire backed with Velin Arches creme
250 gsm;
57.0 x 68.8 cm (22½ x 27⅛ in)

Edition of 75, Peacock Printmakers,
Mercury Gallery, London

12 *Black Cat* 1982 Pl. 48
Lithograph on two stones
I: yellow ochre; II: black
40.0 x 57.5 cm (15¾ x 22⅝ in):
Velin Arches creme 250 gsm;
53.5 x 71.1 cm (21 x 28 in)
Edition of 75, Peacock Printmakers,
Mercury Gallery, London

13 *Still Life with Wooden Puzzles* 1983 Pl. 26
Eleven-colour screenprint with one colour
lithograph
Order unknown: black, blue, magenta, red,
yellow ochre, green, silver, and pale tints of
yellow, pink and green
46.0 x 58.5 cm (18⅛ x 23 in):
Tenjin backed with Arches blanc 250 gsm;
57.0 x 68.5 cm (22½ x 27 in)
Edition of 75, Peacock Printmakers,
Mercury Gallery, London

14 *Hibiscus and Cats* 1985 Pl. 90
Etching, soft-ground etching, spit-bitten
aquatint on steel
Black, red, orange, yellow, inked *à la poupée*
61.0 x 45.7 cm (24 x 18 in):
Somerset satin waterleaf 300 gsm;
72.5 x 55.2 cm (28½ x 21¾ in)
Edition of 50, Glasgow Print Studio

15 *Flower* 1985 Pl. 92
Etching and spit-bitten aquatint on two
steel plates
I: blue; II: black
17.5 x 13.2 cm (6⅞ x 5¼ in):
Somerset waterleaf 300 gsm;
21.8 x 17.7 cm (8⅝ x 7 in)
Edition of 30, Glasgow Print Studio,
Mercury Gallery, Edinburgh and London
Note: originally sold within a specially bound
copy of *Elizabeth Blackadder* by William Packer,
Mercury Gallery, London, 1985,
numbered 1–30.

16 *Landscape in Japan* 1985 Pl. 8
Soft-ground etching on steel
Black
13.0 x 17.8 cm (5⅛ x 7 in):
Somerset waterleaf 300 gsm;
17.3 x 22.0 cm (6¾ x 8⅝ in)
Edition of 30, Glasgow Print Studio,
Mercury Gallery, Edinburgh and London
Note: originally sold within a specially bound
copy of *Elizabeth Blackadder* by William Packer,

Mercury Gallery, London, 1985,
numbered 31–60.

17 *Meconopsis and Butterflies* 1985 Pl. 91
Soft-ground etching and spit-bitten aquatint
on two steel plates
I: blue, sienna; II: black
30.1 x 22.7 cm (11⅞ x 9 in):
Somerset satin waterleaf 300 gsm;
48.0 x 34.3 cm (18⅞ x 13½ in)
Edition of 50, Glasgow Print Studio

18 *Orchid* 1985 Pl. 64
Soft-ground etching with spit-bitten aquatint
on two steel plates
I: red, yellow, green; II: black
50.8 x 32.8 cm (20 x 12⅞ in):
Somerset satin waterleaf 300 gsm;
72.3 x 53.2 cm (28½ x 21 in)
Edition of 50, Glasgow Print Studio

19 *Iris* 1985–6 Pl. 93
Soft-ground etching and etching on steel
Black
19.0 x 24.0 cm (7½ x 9½ in):
Somerset satin 300 gsm;
32.0 x 37.0 cm (12⅝ x 14½ in)
Edition of 50, Glasgow Print Studio

20 *Beetles and Flower Heads* 1986 Pl. 30
Etching on steel
Black
25.0 x 15.2 cm (9⅞ x 6 in):
Somerset satin 300 gsm;
45.4 x 33.0 cm (17⅞ x 13 in)
Edition of 30, Glasgow Print Studio

21 *Japanese Still Life* 1986 Pl. 27
Soft-ground etching, sugar lift and aquatint
on steel
Black
60.4 x 81.9 cm (23¾ x 32¼ in):
Somerset satin waterleaf 300 gsm;
73.2 x 93.4 cm (28⅞ x 36¾ in)
Edition of 20, Glasgow Print Studio

22 *Indian Still Life* 1987 Pl. 32
Soft-ground etching on steel
Black
30.3 x 22.8 cm (12 x 9 in):
Somerset satin waterleaf 300 gsm;
48.0 x 34.0 cm (18⅞ x 13⅜ in)
Edition of 30, Glasgow Print Studio

23 *Indian Still Life (Colour)* 1987 Pl. 33
Soft-ground etching and spit-bitten aquatint
on two steel plates

I: red, green, yellow; II: yellow ochre
30.3 x 22.8 cm (12 x 9 in):
Somerset satin waterleaf 300 gsm;
41.0 x 33.0 cm (16⅛ x 13 in)
Edition of 50, Glasgow Print Studio

24 *Japanese Table* 1987 Pl. 31
Etching on two zinc plates
Top: mid green with plate tone; bottom: yellow
each 10.2 x 15.2 cm (4 x 6 in):
Arches 88 300 gsm;
44.5 x 34.0 cm (17½ x 13⅜ in)
Edition of 50, Glasgow Print Studio

25 *Parrots* 1987 Pl. 34
Etching, soft-ground etching and aquatint
on steel
Black
23.0 x 30.5 cm (9 x 12 in):
Somerset satin waterleaf 300 gsm;
33.2 x 40.7 cm (13 x 16 in)
Edition of 50, Glasgow Print Studio

26 *Lotus Pond – Akita* 1987 Pl. 9
Etching on steel
Black
22.4 x 25.0 cm (8¾ x 9⅞ in):
Somerset satin waterleaf 300 gsm;
35.0 x 38.0 cm (13¾ x 15 in)
Edition of 30, Glasgow Print Studio

27 *Loguivy de la Mer, Brittany* 1987 Pl. 10
Etching on steel
Black
19.5 x 28.2 cm (7¾ x 11 in):
Somerset satin waterleaf 300 gsm;
33.5 x 42.0 cm (13¼ x 16½ in)
Edition of 30, Glasgow Print Studio

28 *Orchid Oncidium* 1987 Pl. 68
Etching, soft-ground etching and spit-bitten
aquatint on steel
Yellow-green, black, inked *à la poupée*
60.5 x 82.3 cm (23¾ x 32⅜ in):
Somerset satin white 300 gsm;
73.0 x 97.5 cm (28¾ x 38⅜ in)
Edition of 50, Glasgow Print Studio
Note: within the edition are a few colour
variants, with the flowers inked in pink, as
illustrated.

29 *Orchidaceae – Dendrobium atroviolaceum*
1987 Pl. 66
Etching and spit-bitten aquatint on steel
Olive to green, violet
60.8 x 45.4 cm (24 x 17⅞ in):
Arches cover buff 300 gsm;

69.7 x 53.0 cm (27½ x 20⅞ in)
Edition of 50, Glasgow Print Studio

30 *Orchidaceae – Brassia gireoudiana I*
1987 Pl. 70
Etching on steel
Black
45.3 x 60.5 cm (17⅞ x 23⅞ in):
Somerset satin waterleaf 300 gsm;
52.8 x 67.0 cm (20¾ x 26⅜ in)
Edition of 10, Glasgow Print Studio

31 *Orchidaceae – Brassia gireoudiana II*
1987 Pl. 71
Spit-bitten aquatint on two steel plates
I: green, yellow-green; II: purple
45.3 x 60.8 cm (17⅞ x 24 in):
Somerset satin waterleaf 300 gsm;
54.0 x 68.3 cm (21¼ x 27 in)
Edition of 50, Glasgow Print Studio

32 *Orchidaceae – Paphiopedilum insigne*
1987 Pl. 65
Etching and spit-bitten aquatint on steel
Black, maroon, yellow, inked *à la poupée*
60.9 x 45.5 cm (24 x 18 in):
Somerset satin waterleaf 300 gsm;
70.2 x 53.2 cm (27⅝ x 21 in)
Edition of 50, Glasgow Print Studio

33 *Orchidaceae – Bulbophyllum rothschildianum*
1987 Pl. 72
Soft-ground etching and spit-bitten aquatint
on two steel plates
I: pink; II: purple, raw umber
44.5 x 60.8 cm (17½ x 24 in):
Somerset satin waterleaf 300 gsm;
53.0 x 68.5 cm (20⅞ x 27 in)
Edition of 50, Glasgow Print Studio

34 *Orchidaceae – Phalaenopsis* 1987 Pl. 67
Soft-ground etching and spit-bitten aquatint
on two steel plates
I: red, green; II: violet, green
59.7 x 45.5 cm (23½ x 18 in):
Arches 88 300 gsm;
71.0 x 54.5 cm (28 x 21½ in)
Edition of 50, Glasgow Print Studio

35 *Orchidaceae – Masdevallia* 1987 Pl. 69
Etching on steel
Warm black
60.9 x 45.5 cm (24 x 18 in):
Somerset satin waterleaf 300 gsm;
69.5 x 53.0 cm (27⅜ x 20⅞ in)
Edition of 30, Glasgow Print Studio

36 *Tillandsia* 1987 Pl. 96
Soft-ground etching and spit-bitten aquatint
on steel
Grey-green, pink, violet, inked *à la poupée*
59.8 x 60.2 cm (23½ x 23¾ in):
Velin Arches blanc *c.* 300 gsm;
79.0 x 76.5 cm (31⅛ x 30⅛ in)
Edition of 50, Glasgow Print Studio
Note: although numbered out of fifty,
editioning ceased when the aquatint began
to break down, probably after 38/50.
No artist's proofs.

37 *Auratum Lily* 1987 Pl. 98
Lithograph on six plates
I: buff; II: yellow; III: sienna; IV: yellow-green;
V: cool green; VI: dark green
67.0 x 56.5 cm (26⅜ x 22¼ in):
BFK Rives 250 gsm; as image
Edition of 75, Peacock Printmakers, the Artist

38 *Still Life with Iris* 1987–9 Pl. 35
Etching, soft-ground etching and spit-bitten
aquatint on two steel plates
I: black; II: purple, two pinks, gold;
with collaged gold leaf
43.0 x 53.2 cm (17 x 21 in):
Somerset satin 300 gsm;
53.3 x 63.5 cm (21 x 25 in)
Edition of 75, Glasgow Print Studio,
National Art-Collections Fund, London
Note: completed and signed in 1988,
published in 1989; twenty-five artist's proofs
numbered I–XXV.

39 *Little Kyoto Still Life* 1988 Pl. 36
Soft-ground etching and spit-bitten aquatint
on two steel plates
I: blue; II: black, red. Relief stamps in red
15.2 x 21.5 cm (6 x 8½ in):
Arches 88 300 gsm;
20.5 x 26.8 cm (8 x 10½ in)
Edition of 60, Glasgow Print Studio,
Mercury Gallery, London
Note: originally sold within a specially bound
copy of *Elizabeth Blackadder* by Judith Bumpus,
Phaidon, Oxford, 1988, numbered 1–60.
The oval seals read 'Nippon'; the square one
'Kyoto'; the round one; ?'EVB'.

40 *Black Cat and Lily* 1988 Pl. 49
Etching and spit-bitten aquatint on two
steel plates
I: black, yellow; II: orange
21.2 x 15.2 cm (8⅜ x 6 in):
Arches 88 300 gsm;
26.8 x 20.5 cm (10½ x 8 in)

Edition of 60, Glasgow Print Studio,
Mercury Gallery, London
Note: originally sold within a specially bound
copy of *Elizabeth Blackadder* by Judith Bumpus,
Phaidon, Oxford, 1988, numbered 61–120.

41 *Little Orchid* 1988–9 Pl. 73
Etching and spit-bitten aquatint on two
copper plates
I: deep yellow; II: red
20.3 x 15.2 cm (8 x 6 in):
Arches 88 300 gsm;
43.2 x 35.5 cm (17 x 14 in)
Edition of 50, Glasgow Print Studio
Note: although numbered out of fifty, editioning
ceased when the aquatint began to break
down, probably after 37/50. No artist's proofs.

42 *Black Iris* 1989 Pl. 97
Soft-ground etching and spit-bitten aquatint
on copper
Black
17.8 x 13.3 cm (7 x 5¼ in):
Arches 88 300 gsm;
38.0 x 32.0 cm (15 x 12⅝ in)
Edition of 30, Glasgow Print Studio

43 *Banksia* 1989 Pl. 94
Etching and spit-bitten aquatint on copper
Black
15.2 x 20.2 cm (6 x 8 in):
Arches 88 300 gsm;
32.0 x 38.0 cm (12⅝ x 15 in)
Edition of 30, Glasgow Print Studio

44 *Two Exotic Fruits* 1989 Pl. 37
Soft-ground etching and spit-bitten aquatint
on three copper plates
I: ochre; II: yellow, purple; III: purple, green
22.9 x 28.0 cm (9 x 11 in):
Arches 88 300 gsm;
34.3 x 38.0 cm (13½ x 15 in)
Edition of 30, Glasgow Print Studio

45 *Little Doorway, Kyoto* 1989 Pl. 38
Etching, soft-ground etching and spit-bitten
aquatint on two copper plates
I: black; II: red, gold.
7.7 x 12.5 cm (3 x 5 in):
Arches 88 waterleaf 300 gsm;
34.0 x 37.7 cm (13⅜ x 14⅞ in)
Edition of 30, Glasgow Print Studio

46 *Fortune Teller, Kyoto* 1989 Pl. 39
Etching and sugar-lift aquatint on copper
Black, red, inked *à la poupée*, with collaged
silver leaf and relief stamps

25.4 x 35.5 cm (10 x 14 in):
Somerset satin 300 gsm;
48.0 x 61.0 cm (18⅞ x 24 in)
Edition of 30, Glasgow Print Studio
Note: the seals read from the top:
'Kyoto', 'Nippon' and ?'Blackadder'.

47 *Irises* 1989 Pl. 99
Lithograph, five printings from one stone
I: yellow-green; II: green; III: buff;
IV: purple to violet blend; V: violet
61.0 x 45.8 cm (24 x 18 in):
BFK Rives waterleaf 275 gsm; as image
Edition of ?175, Edinburgh Printmakers
Workshop, The University of Edinburgh
Note: a large edition commissioned to mark
the 200th anniversary of the University's
Old College.

48 *Red Still Life* 1989 Pl. 40
Soft-ground etching and spit-bitten aquatint
from two steel plates
I: green, brown and yellow; II: red
20.3 x 25.4 cm (8 x 10 in):
Arches 88 waterleaf 300 gsm;
35.2 x 40.7 cm (13¾ x 16 in)
Edition of 50, Glasgow Print Studio,
Aberystwyth Arts Centre
Note: commissioned in conjunction with
the artist's Welsh Arts Council touring
exhibition, 1989.

49 *Cat and Anemonies* 1989 Pl. 51
Etching, soft-ground etching and spit-bitten
aquatint on two copper plates
I: red, purple, buff; II: black
20.0 x 25.3 cm (7⅞ x 10 in):
Arches 88 waterleaf 300 gsm;
35.0 x 40.8 cm (13¾ x 16 in)
Edition of 50, Glasgow Print Studio,
Aberystwyth Arts Centre
Note: commissioned in conjunction with
the artist's Welsh Arts Council touring
exhibition, 1989

50 *Fritillaria imperialis* 1989 Pl. 100
Etching and spit-bitten aquatint on two
steel plates
I: yellow; II: green
75.8 x 51.0 cm (29⅞ x 20⅛ in):
Somerset satin 300 gsm;
101.3 x 71.3 cm (39⅞ x 28 in)
Edition of 50, Glasgow Print Studio

51 *Lilies* 1989 Pl. 95
Woodcut on one block
Mid brown

61.0 x 45.7 cm (24 x 18 in):
Velin Arches blanc 300 gsm;
75.7 x 57.0 cm (29¾ x 22½ in)
Edition of 30, Glasgow Print Studio

52 *Strelitzia* 1989 Pl. 101
Woodcut on one block
Black
76.1 x 61.0 cm (30 x 24 in):
Velin Arches blanc 300 gsm;
105.5 x 75.0 cm (41½ x 29½ in)
Edition of 30, Glasgow Print Studio

53 *Still Life with Lily and Flute* 1990 Pl. 41
Etching, soft-ground etching and spit-bitten
aquatint on two steel plates
I: yellow, yellow ochre, gold, blue-grey;
II: black, red; collaged gold leaf
32.5 x 45.3 cm (12¾ x 17⅞ in):
Somerset satin c. 300 gsm;
50.8 x 64.8 cm (20 x 25½ in)
Edition of 200, Glasgow Print Studio,
Merivale Editions, London
Note: a large edition commissioned to mark
the bicentenary of Mozart's death in 1791;
twenty-five artist's proofs numbered I–XXV.

54 *Konchi-in, Kyoto* 1992 Pl. 42
Etching and spit-bitten aquatint on two
copper plates
I: black, red; II: yellow, green, gold
10.2 x 14.0 cm (4 x 5½ in):
Somerset satin 300 gsm;
33.5 x 34.5 cm (13¼ x 13½ in)
Edition of 50, Glasgow Print Studio

55 *Japanese Garden, Kyoto* 1992 Pl. 11
Etching and spit-bitten aquatint on two
copper plates
I: yellow ochre; II: black
14.2 x 20.0 cm (5⅝ x 7⅞ in):
Somerset satin 300 gsm;
43.5 x 46.0 cm (17⅛ x 18⅛ in)
Edition of 50, Glasgow Print Studio

56 *Blue Iris* 1992 Pl. 102
Soft-ground etching and etching, with
spit-bitten aquatint, on copper
Purple-black, blue, inked *à la poupée*
24.0 x 20.2 cm (9½ x 8 in):
Somerset satin 300 gsm;
62.0 x 51.0 cm (24½ x 20⅛ in)
Edition of 50, Glasgow Print Studio

57 *Three Cats* 1992 Pl. 52
Soft-ground etching, etching and
spit-bitten aquatint on two copper plates

I: orange, yellow; II: black
41.7 × 58.7 cm (16⅜ × 23⅛ in):
Somerset satin 300 gsm;
54.5 × 71.0 cm (21½ × 28 in)
Edition of 50, Glasgow Print Studio

58 *Two Cats* 1992 Pl. 53
Soft-ground etching, etching and
spit-bitten aquatint on copper
Black, brown, inked *à la poupée*
41.5 × 58.7 cm (16⅜ × 23⅛ in):
Somerset satin 300 gsm;
54.5 × 71.2 cm (21½ × 28 in)
Edition of 50, Glasgow Print Studio
Note: ten artist's proofs, including colour
variants.

59 *Fishing Boats at Loguivy* 1992 Pl. 12
Etching on copper
Black
45.5 × 60.7 cm (17⅞ × 23⅞ in):
Fabriano Artistico Not 300 gsm;
54.5 × 70.2 cm (21½ × 27⅝ in)
Edition of 50, Glasgow Print Studio

60 *Orchidaceae – Coelogyne cristata* 1992 Pl. 74
Etching and spit-bitten aquatint on copper
Greenish black, yellow, inked *à la poupée*
30.5 × 35.5 cm (12 × 14 in):
Somerset satin 300 gsm;
53.5 × 56.0 cm (21 × 22 in)
Edition of 40, Glasgow Print Studio

61–70 *The Orchid Portfolio* 1991–3
Solander box, boards covered with olive green linen,
with gold-blocked orchid flower and facsimile signature
'Elizabeth V. Blackadder', made by Carronvale Bindery,
Larbert. Overall dimensions 69.0 × 54.5 × 2.5 cm
(27¼ × 21½ × 1 in). Contents: ten colour etchings with
aquatint and three sheets of text: Title page; Biography
of the artist and list of contents; Introduction by the
artist, with production notes. About twelve portfolio
cases were made; the prints were also available
individually, as described below.

61 *Orchid Portfolio 1.*
Paphiopedilum insigne hybrid 1991–3 Pl. 75
Etching and spit-bitten aquatint on two copper
plates I: two greens; II: purple
35.5 × 30.5 cm (14 × 12 in):
Somerset satin 300 gsm;
63.5 × 51.0 cm (25 × 20⅛ in)
Edition of 40, Glasgow Print Studio

62 *Orchid Portfolio 2.*
Dendrobium 'Fire Coral' 1991–3 Pl. 76
Etching and spit-bitten aquatint on two copper

plates I: purple-grey, red; II: olive green, yellow
35.5 × 30.5 cm (14 × 12 in):
Somerset satin 300 gsm;
63.5 × 51.0 cm (25 × 20⅛ in)
Edition of 40, Glasgow Print Studio

63 *Orchid Portfolio 3.*
Masdevallia coccinea 1991–3 Pl. 77
Etching and spit-bitten aquatint on copper
Red, yellow, green, inked *à la poupée*
35.5 × 30.5 cm (14 × 12 in):
Somerset satin 300 gsm;
63.5 × 51.0 cm (25 × 20⅛ in)
Edition of 40, Glasgow Print Studio

64 *Orchid Portfolio 4.*
Brassia verrucosa 1991–3 Pl. 78
Etching and spit-bitten aquatint on copper
Dark green, pale green, yellow,
inked *à la poupée*
30.5 × 35.5 cm (12 × 14 in):
Somerset satin 300 gsm;
51.0 × 63.5 cm (20⅛ × 25 in)
Edition of 40, Glasgow Print Studio

65 *Orchid Portfolio 5.*
Taeniophyllum latipetalum 1992–3 Pl. 79
Etching and spit-bitten aquatint on copper
Grey-green, orange-red, inked *à la poupée*
35.5 × 30.5 cm (14 × 12 in):
Somerset satin 300 gsm;
63.5 × 51.0 cm (25 × 20⅛ in)
Edition of 40, Glasgow Print Studio

66 *Orchid Portfolio 6.*
Masdevallia dracula bella 1992–3 Pl. 80
Etching and spit-bitten aquatint on two copper
plates I: pale green, yellow; II: dark green, purple
35.5 × 30.5 cm (14 × 12 in):
Somerset satin 300 gsm;
63.5 × 51.0 cm (25 × 20⅛ in)
Edition of 40, Glasgow Print Studio

67 *Orchid Portfolio 7.*
Cambria 'Living Fire' 1991–3 Pl. 81
Etching and spit-bitten aquatint on two copper
plates I: yellow; II: red
35.5 × 30.5 cm (14 × 12 in):
Somerset satin 300 gsm;
63.5 × 51.0 cm (25 × 20⅛ in)
Edition of 40, Glasgow Print Studio

68 *Orchid Portfolio 8.*
Paphiopedilum appletonianum 1991–3 Pl. 82
Etching and spit-bitten aquatint on two copper
plates I: green; II: pink and purple
35.5 × 30.5 cm (14 × 12 in):
Somerset satin 300 gsm;

63.5 × 51.0 cm (25 × 20⅛ in)
Edition of 40, Glasgow Print Studio

69 *Orchid Portfolio 9.*
Odontoglossum grande 1991–3 Pl. 83
Etching and spit-bitten aquatint on two copper
plates I: yellow; II: reddish-brown
35.5 × 30.5 cm (14 × 12 in):
Somerset satin 300 gsm;
63.5 × 51.0 cm (25 × 20⅛ in)
Edition of 40, Glasgow Print Studio

70 *Orchid Portfolio 10.*
Paphiopedilum sanderianum 1991–3 Pl. 84
Etching and spit-bitten aquatint on two copper
plates I: olive green, yellow ochre; II: purple
35.5 × 30.5 cm (14 × 12 in):
Somerset satin 300 gsm;
63.5 × 51.0 cm (25 × 20⅛ in)
Edition of 40, Glasgow Print Studio

71 *Orchidaceae – Phalaenopsis antarctica* 1993
Pl. 85
Etching and spit-bitten aquatint on three
copper plates
I: yellow, green; II: red; III: purple
30.2 × 35.5 cm (12 × 14 in):
Somerset satin 300 gsm;
50.6 × 56.0 cm (20 × 22 in)
Edition of 40, Glasgow Print Studio

72 *Cats and Lily* 1993 Pl. 50
Etching on copper
Umber, sienna, ochre, inked *à la poupée*
35.0 × 27.7 cm (13¾ × 11 in):
Velin Arches blanc 300 gsm;
49.0 × 38.0 cm (19¼ × 15 in)
Edition of 40, Dundee Printmakers Workshop
Note: published within the portfolio
Thursday's Child in aid of the Child
Psychology Trust, Edinburgh.

73 *Irises* 1994 Pl. 104
Etching, sugar lift and spit-bitten aquatint
on copper
Light purple, dark purple, green,
inked *à la poupée*
14.0 × 17.3 cm (5½ × 6¾ in):
Arches 88 blanc 300 gsm;
18.5 × 21.5 cm (7¼ × 8½ in)
Edition of 50, Glasgow Print Studio,
Mercury Gallery, London
Note: originally sold within a specially bound
copy of *Favourite Flowers* by Deborah Kelloway,
Pavilion, London, 1994, numbered 1–50.
Ten artist's proofs were on larger paper:
32.0 × 33.0 cm (12⅝ × 13 in).

74 *Salpiglossis* 1994 Pl. 105
Etching and spit-bitten aquatint on two
copper plates
I: yellow, green; II: red, pink, purple
14.0 x 17.3 cm (5½ x 6¾ in):
Arches 88 blanc 300 gsm;
18.5 x 21.5 cm (7¼ x 8½ in)
Edition of 50, Glasgow Print Studio,
Mercury Gallery
Note: originally sold within a specially bound
copy of *Favourite Flowers* by Deborah Kelloway,
Pavilion, London, 1994, numbered 51–100.
Ten artist's proofs were on larger paper:
32.0 x 33.0 cm (12⅝ x 13 in).

75 *Studies of Cats* 1995 Pl. 54
Drypoint on copper
Warm black
15.0 x 19.5 cm (5⅞ x 7⅝ in):
Zerkall rosa 300 gsm;
38.5 x 40.0 cm (15⅛ x 15¾ in)
Edition of 20, Glasgow Print Studio

76 *Roman Cats* 1995 Pl. 56
Drypoint on copper
Black; with plate tone
9.0 x 10.0 cm (3½ x 4 in):
Zerkall rosa 300 gsm;
26.0 x 27.0 cm (10¼ x 10⅝ in)
Edition of 20, Glasgow Print Studio

77 *Hong Kong Cat* 1995 Pl. 60
Drypoint on copper
Warm black
8.0 x 10.0 cm (3⅛ x 4 in):
Zerkall rosa 300 gsm;
26.0 x 25.5 cm (10¼ x 10 in)
Edition of 20, Glasgow Print Studio

78 *Abyssinian Cat in a Basket* 1995 Pl. 55
Etching and spit-bitten aquatint on two
copper plates
I: ochre; II: black
23.0 x 25.5 cm (9 x 10 in):
Somerset white *c.* 300 gsm;
52.0 x 50.5 cm (20½ x 19⅞ in)
Edition of 70, Glasgow Print Studio

79 *Black and White Cat* 1995 Pl. 59
Etching and spit-bitten aquatint on copper
Black
22.8 x 30.4 cm (9 x 12 in):
Somerset satin 300 gsm;
51.8 x 50.5 cm (20⅜ x 19⅞ in)
Edition of 70, Glasgow Print Studio

80 *The Champion* 1995 Pl. 57
Etching on copper
Black
21.0 x 25.5 cm (8¼ x 10 in):
Somerset satin 300 gsm;
53.0 x 70.0 cm (20⅞ x 27½ in)
Edition of 50, Glasgow Print Studio

81 *Autumn Kyoto* 1996 Pl. 43
Etching and spit-bitten aquatint on two
copper plates
I: green, orange, purple; II: black, purple;
with collaged gold leaf and relief stamps
18.0 x 152.0 cm (7⅛ x 59⅞ in):
Velin Arches blanc 300 gsm; as image
Edition of 30, Glasgow Print Studio
Note: concertina-folded and bound to silk-
covered boards 19.0 x 19.6 cm (7½ x 7¾ in),
by Carronvale Bindery, Larbert. The seals read,
left to right, 'Iris', 'Kyoto' and 'Nippon'.

82 *View of a Garden* 1996 Pl. 44
Etching and spit-bitten aquatint on two
copper plates
I: olive; II: black; with relief stamp
10.0 x 12.0 cm (4 x 4¾ in):
Velin Arches blanc 300 gsm;
17.3 x 18.3 cm (6¾ x 7¼ in)
Edition of 30, Glasgow Print Studio
Note: originally sold only as a loose insert
to 81 above. The seal reads 'Summer'.

83 *Lilium* 1997 Pl. 108
Etching and spit-bitten aquatint on two
copper plates
I: orange, purple, yellow; II: pale green,
dark green
50.0 x 35.0 cm (19¾ x 13¾ in):
Velin Arches blanc 300 gsm;
71.0 x 53.0 cm (28 x 20⅞ in)
Edition of 30, Glasgow Print Studio

84 *Koi Carp, Chion-in* 1997 Pl. 62
Screenprint from *c.* ten screens
4 greens, 3 greys, blue, black, ochre,
cream, red, orange, yellow, order unknown
66.5 x 92.0 cm (26¼ x 36¼ in):
Somerset satin white 300 gsm;
75.0 x 108.5 cm (29½ x 42¾ in)
Edition of 80, Glasgow Print Studio

85 *Tulips* 1997 Pl. 106
Screenprint from *c.* fifteen screens
Twenty-six colours
58.0 x 77.0 cm (22⅞ x 30¼ in):
Somerset satin white 300 gsm;

76.0 x 95.0 cm (29⅞ x 37⅜ in)
Edition of 80, Glasgow Print Studio

86 *Irises* 1997 Pl. 107
Screenprint from *c.* eight screens
3 greens, 2 yellows, 1 blue, 4 from lilac
to purple, order unknown
58.0 x 80.5 cm (22⅞ x 31¼ in):
Somerset satin white 300 gsm;
76.0 x 96.5 cm (30 x 38 in)
Edition of 80, Glasgow Print Studio

87 *Still Life with Pagoda* 1997 Pl. 46
Screenprint from twelve screens
1–4: yellows; 5–6: reds; 7–8: magentas;
9: green; 10–11: greys; 12: cream
41.5 x 59.2 cm (16⅜ x 23¼ in):
Somerset ?satin white 300 gsm;
56.2 x 73 cm (22⅛ x 28¾ in)
Edition of 100, Gresham Studio Ltd,
National Museum of Women in the
Arts (NMWA), Washington DC, U.S.A.
Note: published within a portfolio of
eight screenprints by women artists
commissioned to celebrate the tenth
anniversary (1997) of the NMWA.

88 *Burano* 1997–8 Pl. 13
Etching on copper
Warm black
15.0 x 17.5 cm (5⅞ x 6⅞ in):
Somerset velvet buff 300 gsm;
31.5 x 33.7 cm (12⅜ x 13¼ in)
Edition of 30, Glasgow Print Studio

89 *Fishing Nets, Burano* 1997–8 Pl. 15
Etching on copper
Warm black
8.8 x 30.0 cm (3½ x 11¾ in):
Somerset velvet buff 300 gsm;
29.0 x 48.2 cm (11⅜ x 19 in)
Edition of 30, Glasgow Print Studio

90 *Murano* 1997–8 Pl. 17
Etching on copper
Warm black
8.8 x 30.0 cm (3½ x 11¾ in):
Somerset velvet buff 300 gsm;
29.0 x 48.2 cm (11⅜ x 19 in)
Edition of 30, Glasgow Print Studio

91 *Torcello* 1997–8 Pl. 16
Etching on copper
Warm black
15.0 x 17.6 cm (5⅞ x 6⅞ in):
Somerset velvet buff 300 gsm;

31.3 x 34.0 cm (12⅜ x 13⅜ in)
Edition of 30, Glasgow Print Studio

92 *Piazzetta* 1997–8 Pl. 18
Etching on copper
Warm black
15.2 x 17.7 cm (6 x 7 in):
Somerset velvet buff 300 gsm;
31.5 x 34.0 cm (12⅜ x 13⅜ in)
Edition of 30, Glasgow Print Studio

93 *Koi Carp* 1998–9 Pl. 63
Soft-ground etching and spit-bitten aquatint
on two steel plates
I: yellow, orange; II: blue-black
17.0 x 12.5 cm (6⅞ x 4⅞ in):
Velin Arches blanc 300 gsm;
42.0 x 33.0 cm (16½ x 13 in)
Edition of 60, Glasgow Print Studio

94 *The Lily* 1998–9 Pl. 103
Etching and spit-bitten aquatint on two
steel plates
I: orange, yellow, red; II: green, red (of flower)
17.0 x 12.5 cm (6⅞ x 4⅞ in):
Velin Arches blanc 300 gsm;
25.0 x 20.0 cm (9⅞ x 7⅞ in)
Edition of 100, Glasgow Print Studio,
Scolar Press
Note: originally sold within a special edition,
limited to 100 copies, of *Elizabeth Blackadder*
by Duncan MacMillan, Scolar Press, Aldershot,
1999.

95 *Orchidaceae – Coelogyne cristata* 1999 Pl. 87
Aquatint and carborundum print on four plates
I: yellow; II: pale green and olive; III: dark green
and yellow; IV: embossing
44.0 x 54.5 cm (17⅜ x 21½ in):
Fabriano Rosaspina 250 gsm;
70.5 x 77.5 cm (27¾ x 30½ in)
Edition of 40, Graphic Studio, Dublin
Note: no artist's proofs.

96 *Japanese Interior, Kyoto* 1999 Pl. 45
Carborundum print on four plates
I: buff; II: green; III: grey and red; IV: brown
and black
43.8 x 54.4 cm (17¼ x 21⅜ in):
Fabriano Rosaspina 250 gsm;
70.7 x 77.0 cm (27⅞ x 30⅜ in)
Edition of 40, Graphic Studio, Dublin
Note: no artist's proofs.

97 *Tempio dei Castori, Rome* 1999–2000 Pl. 22
Carborundum print on three plates
I: grey-blue, yellow; II: brown; III: black

19.0 x 18.7 cm (7½ x 7⅜ in):
Fabriano Rosaspina 250 gsm;
38.5 x 35.5 cm (15⅛ x 14 in)
Edition of 10, Graphic Studio, Dublin
Note: no artist's proofs.

98 *Dogana, Venice* 1999–2000 Pl. 19
Carborundum print on three plates
I: pink; II: grey; III: dark brown;
with collaged gold leaf
18.2 x 28.5 cm (7⅛ x 11¼ in):
Fabriano Rosaspina 250 gsm;
33.3 x 43.5 cm (13⅛ x 17⅛ in)
Edition of 10, Graphic Studio, Dublin
Note: no artist's proofs.

99 *Roman Cats II* 1999–2000 Pl. 58
Drypoint on copper
Warm black
8.0 x 10.0 cm (3⅛ x 4 in):
Somerset velvet buff 250 gsm;
23.8 x 23.6 cm (9⅜ x 9¼ in)
Edition of 40, Glasgow Print Studio

100 *Fred* 2000 Pl. 61
Drypoint on copper
Warm black
8.5 x 14.0 cm (3⅜ x 5½ in):
Somerset velvet buff 250 gsm;
30.8 x 33.7 cm (12⅛ x 13¼ in)
Edition of 40, Glasgow Print Studio

101 *Venice: High Tide* 2000 Pl. 14
Etching on copper
Warm black
10.0 x 17.5 cm (4 x 6⅞ in):
Somerset velvet buff 250 gsm;
37.8 x 37.5 cm (14⅞ x 14¾ in)
Edition of 50, Glasgow Print Studio

102 *Basilica San Petronio, Bologna* 2000 Pl. 20
Etching on copper
Warm black
10.0 x 17.5 cm (4 x 6⅞ in):
Somerset velvet buff 250 gsm;
37.5 x 37.5 cm (14¾ x 14¾ in)
Edition of 50, Glasgow Print Studio

103 *Orchid Paphiopedilum* 2000 Pl. 86
Etching and spit-bitten aquatint on copper,
inked *à la poupée*
Olive to dark green, purple
30.0 x 8.8 cm (11¾ x 3½ in):
Hahnemuhle natural 300 gsm;
60.0 x 36.5 cm (23⅜ x 14⅜ in)
Edition of 60, Glasgow Print Studio

104 *Orchid Miltonia No. I* 2000 Pl. 88
Etching and spit-bitten aquatint on two
copper plates
I: green and yellow; II: red and purple
38.0 x 43.0 cm (15 x 17 in):
Somerset satin white 300 gsm;
52.5 x 56.0 cm (20⅝ x 22 in)
Edition of 60, Glasgow Print Studio

105 *Orchid Miltonia No. II* 2000–1 Pl. 89
Etching and spit-bitten aquatint on copper
Black
38.0 x 43.0 cm (15 x 17 in):
Velin Arches blanc 300 gsm;
63.0 x 63.5 cm (24¾ x 25 in)
Edition of 60, Glasgow Print Studio

106 *Iris – Hermodactylus tuberosus* 2000–1 Pl. 109
Etching and spit-bitten aquatint on two
copper plates
I: green; II: purple
32.0 x 24.0 cm (12⅝ x 9½ in):
Somerset satin white 300 gsm;
56.0 x 44.0 cm (22 x 17⅜ in)
Edition of 60, Glasgow Print Studio,
Napier University, Edinburgh
Note: published within the portfolio
John Napier 450th Anniversary Original Print Edition
in various media by ten artists. No artist's proofs.

107 *The Forum, Rome* 2000–1 Pl. 21
Etching and spit-bitten aquatint on copper
Warm black
14.7 x 17.8 cm (5¾ x 7 in):
Somerset satin white 300 gsm;
38.0 x 38.0 cm (15 x 15 in)
Edition of 50, Glasgow Print Studio

108 *Tempio dei Castori* 2000–1 Pl. 23
Etching and spit-bitten aquatint on copper
Warm black
15.3 x 18.0 cm (6 x 7⅛ in):
Hahnemuhle natural 300 gsm;
38.0 x 38.0 cm (15 x 15 in)
Edition of 50, Glasgow Print Studio

109 *Still Life with Boxes* 2001 Pl. 47
Screenprint in eleven colours from seven
screens – 3 yellows, 2 ochres, 4 reds,
grey, brown, with collaged silver leaf
43.0 x 64.0 cm (17 x 25¼ in):
Somerset textured white 300 gsm;
52.0 x 72.3 cm (20½ x 28½ in)
Edition of 50, Glasgow Print Studio
Note: published within the portfolio
SPACE (BLUE) in various media by six artists.

Chronology

1931
24 September, born in Falkirk. Attended Falkirk and Strone primary schools, Dunoon Grammar School and from 1943–9, Falkirk High School

1949–54
Studied for the degree of MA in Fine Art at the University of Edinburgh and Edinburgh College of Art, graduating with First Class Honours in 1954

1954
Awarded Carnegie travelling scholarship by the Royal Scottish Academy, visiting Italy, Greece and Yugoslavia

1954
Awarded Andrew Grant post-graduate scholarship at Edinburgh College of Art, for the academic year 1954–5

1955–6
Awarded Andrew Grant travelling scholarship by Edinburgh College of Art. Based in Italy from July 1955 till the following spring. Resultant work exhibited at the College on her return

1956
Married John Houston and moved to London St, Edinburgh. Appointed part-time lecturer at Edinburgh College of Art for two years. Elected member of the Scottish Society of Artists

1958
Selected by Scottish Arts Council to make first lithographs at Harley Brothers, Edinburgh. Travelled to Spain, visiting Barcelona and Madrid

1958–9
Teacher training course at Moray House, Edinburgh. Taught at St Thomas of Aquin's School, Edinburgh. First solo exhibition, 57 Gallery, Edinburgh, 1959

1959–61
Appointed librarian, Fine Art and Archaeology Departments, University of Edinburgh. Commissions for lithographs by St George's Gallery Prints and Museum of Modern Art, New York, printed at Curwen Studio, 1960. Elected member of the Royal Scottish Society of Painters in Watercolour, 1961

1962
Appointed full-time lecturer at Edinburgh College of Art. Guthrie Award, Royal Scottish Academy. Commission for lithographic poster from GPO, proofed at Curwen Studio. Travelled through Greece to Istanbul

1963
Elected Associate of the Royal Scottish Academy, Edinburgh. Commission for lithographs of Hadrian's Wall from St George's Gallery Prints, printed at Curwen Studio. Moved to Queen's Crescent, Edinburgh. Travelled in France

1964
Visited southern France

1965
First solo exhibition at Mercury Gallery, London. Visited southern France

1966
Visited Portugal

1967
Commission for tapestry design from Mrs John Noble and the Scottish National Gallery of Modern Art, woven at the Edinburgh Tapestry Company. Visited Spain and Portugal

1968
Visited Holland and Germany

1969
Visited United States of America, painting at Racine, Lake Michigan

1971
Elected Associate of the Royal Academy, London. Visited Switzerland

1972
Elected Academician of the Royal Scottish Academy, Edinburgh. Visited Switzerland, Austria and southern Germany

1973
Painted in Switzerland

1974
Painted in the Isle of Harris

1975
Moved to Fountainhall Road, Edinburgh, thereafter developing garden as a source of material for work

1976
Elected Academician of the Royal Academy, London. Travelled in Italy

1977
Visited Vienna

1979
Commission for two lithographs from Mercury Gallery, printed at Senefelder Press. Painted on the northern coast of France

1980
Commission for tapestry design from Edinburgh Tapestry Company. Painted in Normandy and Brittany

1981
First retrospective exhibition, the Fruitmarket Gallery, Edinburgh, and Scottish Arts Council tour

1982
Awarded OBE. Commission for two lithographs and a screenprint from Mercury Gallery, printed at Peacock Printmakers. Visited Toronto and New York

1983
Received Pimm's Award, Royal Academy. Visited New York and southern France

1984
Commission for tapestry design in two parts from Reckitt and Colman, woven at the Edinburgh Tapestry Company. Visited Berlin. Elected member of the Royal Glasgow Institute of the Fine Arts

1985
First visit to Japan. Began making etchings at Glasgow Print Studio. Commission for two etchings from Mercury Gallery. Elected Honorary Member of the Royal West of England Academy

1986
Retired from Edinburgh College of Art. Visited Japan. Elected Honorary Fellow of the Royal Incorporation of Architects in Scotland

1987
Commission for a portrait of Molly Hunter from the Scottish National Portrait Gallery. Portrait of Lady Naomi Michieson purchased by the National Portrait Gallery, London. Commissions for tapestry designs from the Edinburgh Tapestry Company. Commission for an etching from the National Art-Collections Fund, printed at Glasgow Print Studio. Commission for a painted window from the National Library of Scotland

1988
Joint winner, Watercolour Foundation Award, Royal Academy. Honorary Doctorate, Heriot Watt University,

Edinburgh. First monograph on her work to date, by Judith Bumpus, published by Phaidon Press. Commission for two etchings from Mercury Gallery, printed at Glasgow Print Studio

1989
Second retrospective exhibition, Aberystwyth Arts Centre and Welsh Arts Council tour. Commission for two etchings from Aberystwyth Arts Centre, printed at Glasgow Print Studio. Commission for a lithograph from the University of Edinburgh, printed at Edinburgh Printmakers Workshop. First woodcuts made in Glasgow

1990
Honorary Doctorate, University of Edinburgh. A series of monoprints made at Glasgow Print Studio

1991
Commission for tapestry design from Scottish Provident, woven at the Edinburgh Tapestry Company. Commission for a portfolio of ten etchings of orchids from Glasgow Print Studio

1992
Elected Honorary Member of the Royal Watercolour Society, London. Visited Japan

1993
Commission for postage stamp designs of orchids by Royal Mail. Visited Japan

1994
Elected Honorary Fellow of the Royal Society of Edinburgh. Elected Honorary Member of the Royal Society of Painter-Printmakers. Commission for a portrait of Sir David Smith from the University of Edinburgh. Collaboration with Deborah Kellaway on the publication *Favourite Flowers*, published by

Pavilion. Commission for two etchings from Mercury Gallery, printed at Glasgow Print Studio

1995
Visit to Penang, Malaya, to paint orchids. Commission for postage stamp designs of cats from Royal Mail. First drypoints made in Glasgow

1997
Honorary Doctorate, University of Aberdeen. Commission for a screenprint from the National Museum of Women in the Arts, Washington DC, printed at Gresham Studio

1998
Honorary Doctorate, University of Aberdeen. Commission for an etching from Scolar Press, printed at Glasgow Print Studio

1999
Second monograph on her work to date, by Duncan Macmillan, published by Scolar Press. First carborundum prints, made at Graphic Studio, Dublin

2000
Third retrospective exhibition, Talbot Rice Gallery, University of Edinburgh. Commission for an etching from Napier University, Edinburgh, printed at Glasgow Print Studio

2001
Appointed Her Majesty the Queen's Painter and Limner in Scotland. Honorary Doctorate, University of Glasgow. Commission for a screenprint from Glasgow Print Studio

2002
Honorary Doctorate, University of Stirling